Insights into American History

Insights into American History
Photographs as Documents

Robert M. Levine
University of Miami

PEARSON

Prentice
Hall

Upper Saddle River, New Jersey 07458

Library of Congress Cataloging-in-Publication Data
Levine, Robert M.
 Insights into American history : photographs as documents / Robert M. Levine.
 p. cm.
 ISBN 0-13-048044-4
 1. United States—Historiography. 2. United States—History—Pictorial works. 3. United
States—History—Sources. 4. Documentary photography—United States. 5. Photography in
historiography. 6. Historiography—Methodology. I. Title.

E175.7 .L48 2004
973'.022'2—dc21 2002038176

VP, Editorial Director: *Charlyce Jones Owen*
Senior Acquisitions Editor: *Charles Cavaliere*
AVP, Director of Production and Manufacturing: *Barbara Kittle*
Editorial/Production Supervision and Interior Design: *Harriet Tellem*
Prepress and Manufacturing Manager: *Nick Sklitsis*
Prepress and Manufacturing Buyers: *Sherry Lewis/Tricia Kenny*
Marketing Manager: *Heather Shelstad*
Editorial Assistant: *Adrienne Paul*
Image Permissions Coordinator: *Joanne Dippel*
Image Specialist: *Beth Boyd-Brenzel*
Manager, Rights and Permissions: *Zina Arabia*
Director, Image Resource Center: *Melinda Reo*

This book was set in 11/13 Paladino by Interactive Composition Corporation,
and was printed and bound by Phoenix Book Tech. The cover was printed by
Phoenix Color Corp., Hagerstonwn, MD.

© 2004 by Pearson Education, Inc.
Upper Saddle River, New Jersey 07458

Printed in the United States of America
10 9 8 7 6 5 4 3 2 1

ISBN 0-13-048044-4

PEARSON EDUCATION LTD., *London*
PEARSON EDUCATION AUSTRALIA PTY, LIMITED, *Sydney*
PEARSON EDUCATION SINGAPORE, PTE. LTD.
PEARSON EDUCATION NORTH ASIA LTD., *Hong Kong*
PEARSON EDUCATION CANADA, LTD., *Toronto*
PEARSON EDUCATION DE MEXICO, S.A. DE C.V.
PEARSON EDUCATION—JAPAN, *Tokyo*
PEARSON EDUCATION MALAYSIA, PTE. LTD.
PEARSON EDUCATION, UPPER SADDLE RIVER, *New Jersey*

Dedication

To Sidney Sorkin, for his patience a long time ago
with a kid interested in photography.

In Memoriam

Robert M. Levine
1941–2003

Contents

Preface

Paul Byers, a professional photographer and Columbia University anthropologist, argued a generation ago that of all communications media, still photography was the least studied and least understood. Byers' words may be true, but this book argues that photographs inform historical research. It seeks to guide readers through the analytical process.

We need such a guide. Excellent books and scholarly articles have been written on the history of photography and on ways of interpreting photographic images, mainly from the standpoint of art. For a list of these sources, see suggestions for further study at the end of this book. What makes this book different, however, is its focus on reading photographs for their intrinsic historical value. This is the goal of *Insights into American History*.

Photographs may show society in ways considered offensive today, but which to contemporary viewers of the era seemed perfectly normal. Analysis of images helps us understand social values and ways of perceiving past times. This characteristic, of course, goes both ways. To some, photographs provide novel information about the culture portrayed; to others, the viewer's knowledge of the larger culture gives the pictures meaning.

Whichever side one chooses, this book argues that when photographs are examined carefully, just as when examining any other historical document, they can bring insight to historical interpretation. The problem is that no accepted criteria exist for studying photographs forensically—that is, as sources for information about society past and present. We describe pictures as "saying" something, or "suggesting this or that," but we have few concrete guidelines to proceed. Yet photographs provide invaluable clues, sometimes overlooked, about the past. They reveal to us the ways earlier generations saw themselves. Photographic styles reflected social conventions, and thus provide insight about the times. This book argues that photographs do not "speak," but that they provide an infinite number of hints that awaken our own powers of interpretation. Photographs, as well, may be arresting artistic compositions, but it is in their ordinariness—their detailed description of how things were, how people lived, what they wore, how they cut their hair, whether they protected their eyes while performing industrial work, whether small children toiled in rural fields—that they become historical documents of inestimable value.

Historical photographs—found in boxes in attics, in museums, and at flea markets—are not the only visual images that "cameras" recorded. Very recently, scholars have discovered that some of history's great painters—going back as far as the thirteenth century—relied on projection devices

that projected images by concave mirrors to trace subjects. Curators at the Philadelphia Museum of Art now believe that Thomas Eakins' painting, "Sailboats Racing on the Delaware," and his 1885 masterpiece "The Swimming Hole," used Victorian projection devices, versions of candle-lit magic lanterns, to create collages that were traced using compass lines on a single canvas.[1] Seventeenth-century Dutch painter Johannes Vermeer likely projected images on his canvases to add a realistic sense of perspective.

To be useful for historical analysis, a photograph does not have had to be taken by a famous photographer. Appropriate images range from framed photographs in museums to snapshots taken with a Brownie (a 1900s predecessor of the Instamatics of the 1970s and today's point-and-shoot cameras) and stored in a family album. A photograph is a document, just as is a diary, an old newspaper, a court decision, a property deed, or a last will and testament. Photographs in themselves cannot offer the final word on a historical argument, but, like other documents, can contribute to a historical judgment.

Photographic commentator Ralph Hattersley once remarked that when we look at a photograph, "we are also looking indirectly at the person who made it." No two photographs are alike, because each photographer produces a different image. Why the subjects are posed in a certain way, how the angle of view affects the image's impact, whether the subject is in sharp focus, or blurred, or captured in an unexpected manner—all reflect the decision of the photographer to make the photograph in a specific way.

During the decades from the late nineteenth century to the 1940s, more than anything else, photographs brought the news of the world to ordinary people. At the turn of the century, families gathered in parlors to view stereopticon cards placed in hand-held devices that gave a lifelike three-dimensional effect.

The photograph on page xi depicts a street in San Francisco's Chinatown district, after the California city's devastating April 1906 earthquake. What information can we ascertain from the photograph? How does it help us understand this point in time?

"Reading" photographs as documents should be a "hands-on" experience. But although we may attempt to describe our feelings about photographs, we lack agreed-upon rules with which to evaluate them. Bookstores and libraries devote many shelves to photography. Photographs include visually powerfully images, but few guides have been written helping researchers to understand how to work with photographic information.

That is the aim of this book.

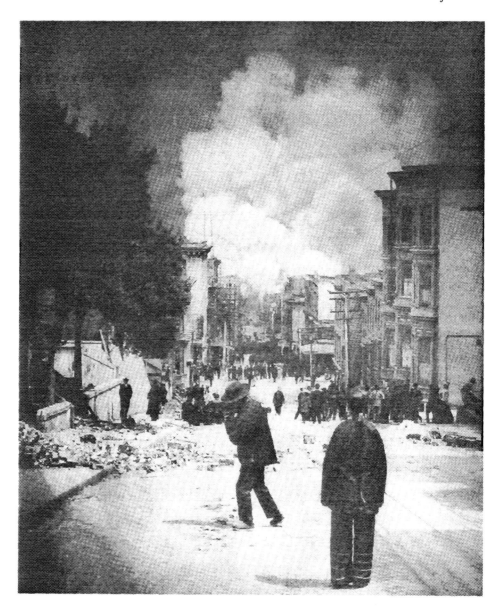

Acknowledgments

I would like to thank the following persons who read portions of "drafts" of this manuscript and who offered their feedback and suggestions: Ashley Helen Atwell, Edward E. Baptist, Joe Bauman, Bill Becker, Thomas Born, Michael Carlebach, John Crocitti Jr., David Culver, Noreen Frye, Andrew Greenlee, Janice Hirshon, Craig Likness, Dolores Newton, Michael LaRosa, Charley Ann Rhoads, Randi Sidman-Moore, Lily and Sidney Sorkin. Special thanks go to Charles Cavaliere, who acknowledged the project's promise and who offered his support all the way through the process.

Many thanks to the following reviewers: Craig Hendricks, Long Beach City College; Maureen Murphy Nutting, North Seattle Community College; Carolyn Eisenberg, Hofstra University; Lyman Johnson, University of North Carolina, Charlotte; Daniel Czitrom, Mt. Holyoke College; and Edward Baptist, University of Miami.

Insights into American History

A daguerreotype of three unknown women, possibly sisters, that was carried by a soldier and found on the battlefield at Port Hudson, Louisiana in 1863.

I

Introduction:
Photographs as Documents

Photography as we know it today evolved from the stunning discovery of the process announced to the world in 1839 by Frenchman Louis Jacques Mandé Daguerre (1787–1851). Daguerre learned to fix images etched onto sensitized coated metal plates that produced detailed and permanent reproductions of the subjects captured by his lens.

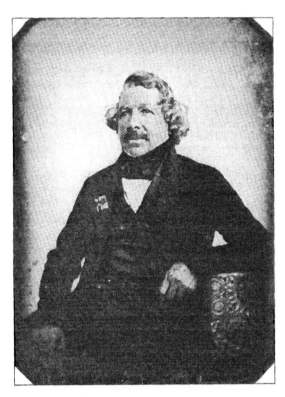

By 1840, a year after the worldwide distribution of Daguerre's formula for daguerreotype, itinerant photographers, many from continental Europe, had traveled to the United States, where they opened photographic studios. They also took their daguerreotype equipment on trips to the interior of the country, photographing natural wonders, groups of indigenous peoples, and the bustling settlements on the frontier, setting out to document the growth of the new nation. Many of these first daguerreotypists stayed, became citizens, and founded businesses that lasted for decades, often kept in the same family for generations.

By the 1850s, revolutionary changes in photographic technology allowed photographers to produce millions of studio photographs annually; they sold cartes de visites, small likenesses similar to the snapshots of today, to ordinary people. The low cost of these photographs permitted consumers to have images of their loved ones in their homes, to exchange photographs, and to collect sets of photographs of faraway places and scenes unknown to them. Modern photography had been born.

THINK ABOUT THIS

How did the daguerreotype's technological limitations (the need for subjects to pose for long periods of time; the need for controlled light; the impossibility of making copies; the fact that images were reversed left-to-right) affect the output of daguerreotypists? Despite these limitations, why did the introduction of daguerreotypes and other early forms of photography so electrify ordinary people around the world?

One remarkable image, dating from the early 1847s and attributed to Southworth and Hawes, is titled "Operation Under Ether." It shows a scene at one of the earliest uses of anesthesia by surgeons, in this case at Harvard University Medical School.

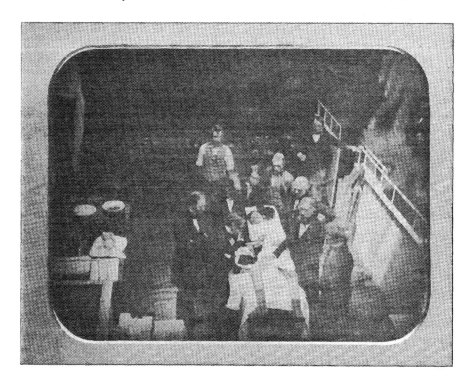

THINK ABOUT THIS

What does the dress worn by the surgeons, the patient, and the others in attendance suggest about the sanitary conditions of the operation? (See previous page)

Somewhat later, when the daguerreotype process had been mastered by studio technicians with a flair for business, daguerreotypists learned to pose their subjects with patience and skill. Early daguerreotype portraits showed people with stiff visages, although a few managed to capture the personality even of children who sat for them. Consider this daguerreotype dating from the 1850s:

Bill Becker, of the virtual American Museum of Photography (AMP) found this instruction left for daguerreotypists:

"[The daguerreotypist]," it said, "must aim to be cheerful and pleasant under all circumstances, and especially patient and playful with children . . . "

For further study, see: the National Memory Website of the Library of Congress, http://memory.loc.gov/ammem/daghtml/daghome.html, as well as the Website maintained by the National Daguerrean Society at http://www.daguerre.org/home.html

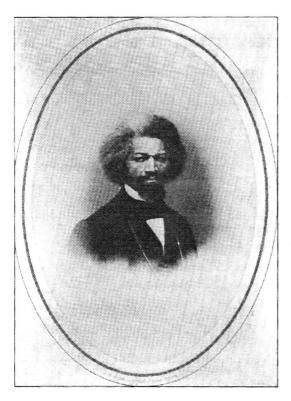

The Library of Congress owns this rare photographic image of the African American abolitionist Frederick Douglass.

Photography's Evolution

Although men and women 150 years ago believed photographic images to be "scientific," and therefore without exception "objective," today we understand that all photographic images are subjective, that they cannot be entirely "objective." We know that pictures may be cropped, subjects altered by lens angle or creative use of light, or digitized to show whatever the photographer wants to show. We know that most photographs, far from being literal reproductions, are actually contrived, as composed as a piece of writing. We often look at photographs and draw conclusions: "He really looked upset in that photograph"; or, "She looks glowing in that picture"; or "That fellow looks like a troublemaker." We also make demands of photographs: "to complain of a photograph for being literal and merciless, is like complaining of a good memory that it will not suffer you to forget your sins."[2]

Photographs have rarely been considered as valuable as paintings, although since the beginning of the 1990s, vintage photographs by famous photographers have risen dramatically in monetary value. Some of the most extensive collections of historical photographs in the world were assembled from years of culling through flea markets and from photographs found at the bottom of boxes of books sold by weight. Photographs are difficult to evaluate. They possess a kind of visual impact lacking in most other forms of representation. They *appear* to be accurate; our eyes "tell" us to believe what we see because our *brain* corroborates this instruction. In other words, we are conditioned to register information as accurate or not.

By themselves, then, photographic images range from works of artistic power to humdrum snapshots. There are thousands of different kinds of

photographs, used by practitioners of medicine, dentistry, genealogy, therapy, human kinetics, botany, and so on. Over the years, photographic images have been transferred to, or reproduced on, metal, glass, coated paper, cloth, and ceramics. For decades photographs have been used in the courtroom as evidence, often both by prosecution and defense in the same case. A famous photograph used as evidence in a 1940s murder trial was shown to have had the hands of a clock changed. Fire department photographs of destroyed buildings and arson scenes always include the supervising fireman's badge in the corner of the photograph. This offers evidence that the scene was properly recorded. Police photographs of crime scenes always note the camera used, the lens, and any other information that suggests that care was taken to achieve accuracy. Forensic tests etch patterns of DNA strings on photographic plates. Expert witnesses are often asked to decode the date embedded on the emulsion layer of Kodak or Polaroid film, or to testify whether retouching dyes, or airbrushing, has been used.

We can take courses to study how to appreciate—and how to analyze—painting, sculpture, architecture, and "art" photographs. We can learn how to *make* photographs: how to use cameras, lenses, darkroom equipment, digital-imaging software. Critics like Max Kozloff have written that photographic images can help "jumpstart our moral imagination." But there are few courses on how to *read* photographs, especially for those using photos as a way to research the past.

Photographs do not "talk," but they fuel the imagination of the viewer and offer clues to social meaning. Consider this 1912 photograph of "Dreamland," a movie theater at New York's Coney Island (see next page). On the surface, the scene seems to show a small business and its employees. But the name is enigmatic enough to suggest more.

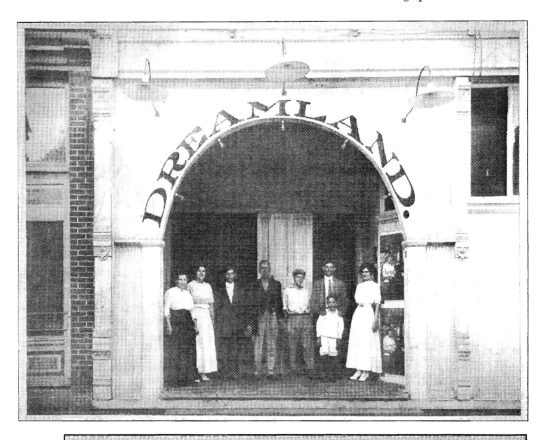

THINK ABOUT THIS

Might the fact that Coney Island, with its amusement parks, sideshows, and distractions, was extremely popular with immigrant families add further meaning to this photograph? Look closely and examine the two movie posters above and behind the woman in a white dress standing at the right side of the photograph. What is suggested by this "image within an image" in the larger photograph?

Photographs do not "talk." We impart meaning to photographic images based on our life experience, motives, and responses to visual stimuli. What we see reflects to some degree our mind's capacity to filter images and to associate them in ways consonant with our individual perspective.

We rely on memory to provide the context in which we examine photographs for meaning. However, memory, according to recent psychological research, often misleads. Psychologists are learning that memory can be

astonishingly unreliable. When we remember traumatic events in our lives—say, the 1941 attack on Pearl Harbor, or the 1986 Challenger disaster, or the September 11, 2001 attacks on the World Trade Center and Pentagon—we display what researchers term "flashbulb memory." This triggers visions in our minds that are "detailed and almost indelible."[3] In spite of the fact that these memories are so vivid, they often turn out to be inaccurate. The lesson here is this: When viewing a photograph "brings back" memories that seem to explain the context of the photograph, exercise caution in drawing conclusions. We may use photographs to mirror our reactions, but only if we recognize them as such.

To be most useful, we have to learn about the context in which the photographs were used. Rather than guess at what the photographer intended to *say*, it is more useful to measure our own reaction and to guess at the reaction of contemporary viewers at the time. In addition, photographs provide us with detailed information about what anthropologists call "material culture," details of great value to historians. Photographs can teach us about how people saw things in the past, about how they carried messages about what was "good" and what was "bad." If we accept our cultural biases, and resist the temptation to project our own personalities *into* the image, we may well be able to decipher the conventions that influenced the photographer to compose the image as it was presented. Lack of information about this context produces ambiguity, and reduces the opportunity to interpret the image with accuracy. In sum, in every case we must ask, "Why do we think the photograph was taken?" and "What kind of information does it offer?"

In considering a photograph as a document for research, the pedigree of the image (Who took it? Who was the subject? When was it taken? How striking is its composition?) is *less* important than the information the photograph contains. For the purpose of historical analysis, it does not matter whether a photograph is an original print or a good quality reproduction. It may be found on the wall of a gallery or at a flea market. It would be possible to analyze discarded photographs found in dumpsters outside of one-hour photo labs.

THINK ABOUT THIS

Are *all* photographs potentially useful? If not, why? If so, why and to what degree? What factors go into our choosing which pictures in a roll to keep and which to discard? What do we look for in snapshots we take?

Historians, conditioned to work with "dead" written documents for the most part, have long ignored photographic evidence in their research. The vast majority of historians use photographs to illustrate, not to analyze. The photographs are then reproduced on shiny paper and bound into the book, often in the middle. Usually, the photographs are captioned, dated, and dismissed. Rarely are they discussed in the text; more rarerly still are they analyzed. Many readers skip over them, or give them a cursory glance. If they do examine the photographs, they are left to their own devices to interpret them. If the author fails to analyze photographs in a book or an article, why should the reader try? This becomes not only a challenge but also a useful resource for historical insight.

The following sections discuss ways of using photographs for research in historical context. Read them and consider the issues they raise. Then proceed to the case studies. Captions will be cited if known, as well as the image's estimated date. Sometimes comparisons will be made with other photographs in the book.

Examine each photograph carefully and "read" it before looking at the printed comments. You may well derive facts from these photographs that the author does not mention. This is fine. Your explanation may be just as insightful as the author's, as long as it is based on detail from within the photographic image and, as much as is possible, is corroborated by ancillary contextual information from other sources.

Sample Work Form

Those interested in sharpening their tools of analysis would do well to begin with a standardized form to facilitate and sharpen discussion. Take at least one full minute to consider each task:

- What is the picture about?
- What are the main objects in the picture?
- How do the people in the picture relate to one another?
- To what extent did the photographer—using composition, lighting, angle of view, etc.—"construct the scene" to create an impression for the viewer? What likely was the photographer's intent?
- Roughly when was the photograph taken? Where? (if not known where exactly, what kind of place?)
- How might a similar scene be different if shot a generation later?

The form that follows has been filled in as an example, based on this photograph.

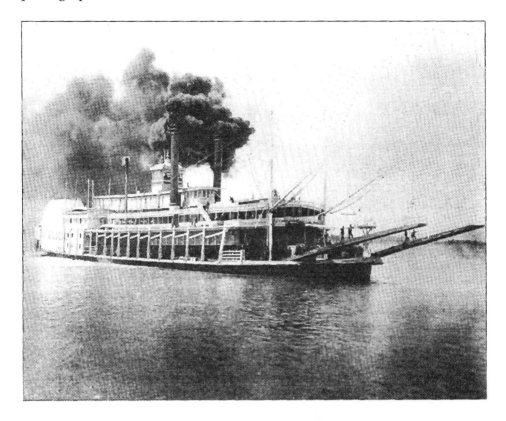

- The photograph of a steamboat chugging along the Missouri River, may suggest to viewers the raw power of nineteenth-century technological prowess, and the opening of the west to settlement.
- The steamboat is belching an enormous cloud of black smoke into the atmosphere. Did the photographer consider this to be an element signifying energy, or could he have waited until the steam turbine had stopped so that the smoke would not be visible? The photograph may date from the turn of the twentieth century, since by the 1920s, stereopticon images had lost their popularity to cinema.
- Fifty years later, would such pollution be permitted in a public space?

How to Start

Answering the questions below is a good place to begin an analysis of the photographed image.

I. Internal Information:
1. Does the subject appear "realistic" or distorted? Is the lighting natural? If you have access to the negative, was it printed full-frame, or cropped?
2. Is the presentation of the subject what might be expected, or does the image contain unexpected nuances?
3. What might the photographer want the audience to see?
4. What material evidence does the image provide? Does the photograph contain details unique to its subject? What about body language of the subjects, or facial gestures, or implied relationships?

II. External Information:
1. What do we know about the time, place, occasion, and circumstance of the photograph? Do we have supporting information such as a caption or information written on the back? Do we know if this information was added later, or was it suggested by the photographer?
2. Do we know anything else about the photograph? Is it an original print? Or a reproduction made later? Do we have any information about the photographer's intent (perhaps the photographer worked for a social agency, or a corporation?) Or the subject's intent (perhaps the subject had the picture taken for business reasons, or for publicity).
3. What can we surmise about the historical period in which the photograph was taken? Does the information contained in the photograph contradict (or agree with) photographs taken by other photographers during roughly the same period, in a similar location?
4. What might have been the social perception of the image during that period? For example, photographers before World War II often depicted African Americans in ways considered disparaging today, because society did not care about the sensibilities of people then known as Negroes.
5. When we evaluate pictures of cultures or social groups different from ours, we must take care not to judge ethnocentrically the values and practices of the depicted culture, compared to our own standards.

Activity

Using the criteria on page 13, search a source of photographs (an archive, a private collection, or published collection) for examples of images that may be analyzed according to these criteria.

Carefully examine sample photographs found in a historical association's archive. Visitors are usually allowed to browse through collections, which are indexed by subject. If they find a photograph they would like to have copied, this can be done for a nominal fee. In the future, many if not most photographic archives will be digitalized and accessible over the Internet. Use the previous guidelines for analysis.

Consider this example:

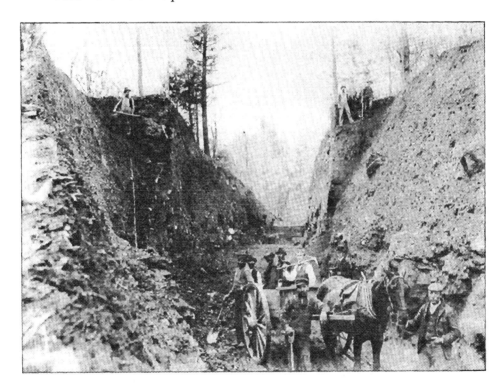

Minus a caption, the photograph itself would provide only general information about when it was taken and nothing about the place. The men's clothing suggests that the picture was taken about a hundred years ago. Like many historical society photographs, this one has a caption—although many other historical photographs do not. The caption reads: "Road Bed Cut for Trolley, Herkimer County, 1904." A bit of research (try

the Internet or an atlas of the United States) will reveal that Herkimer County is in New York State.

The central subject of this photograph, as described by the caption, is the immense gorge dug by men using shovels. The horse-drawn wagon apparently carried away the dirt taken from the excavation. The company hired to take the photograph specialized in industrial work, and the cameraman presumably posed the men atop the bluff on either side of the gorge not so much to show them as to show the vast scale of the earth removal project.[4]

Although it may have been posed, the photograph seems "realistic"—there is no evidence that anything has been added to the composition, or rearranged. As far as we can tell, the negative was printed full frame, since the photographer likely wanted to show the scene in as panoramic a way as possible. The presentation seems logical; unlike some photographs from the same period, the photographer did not seem to want to make a social point. The photograph seems to have been intended to show "progress"—in this case, a roadbed cut for a new trolley system. Perhaps it was taken as publicity for the company holding the construction contract. We know that urban expansion during the first years of the twentieth century in America involved civic pride and that even small cities and towns aspired to have modern public conveniences: street lighting, sanitary water supplies, and public transportation. Although the construction methods were not "modern"—the men used shovels and picks, and a horse pulled the cart—the photograph testifies to the spirit of progress that permeated American life at that time.

Consider, as well, the social information provided by the way the individuals in the photograph are dressed and where they appear. Not only do the workers pose with their tools and the young man in charge of the cart stands leaning on his horse, but a man in a derby and three-piece suit stands behind the cart holding what might be an account book or ledger. And the white-shirted man not wearing a hat, but with a much lighter complexion than most of the workers, may have been an official or office worker whose holding of a pick was ceremonial, because his skin was not exposed to the elements during physical outdoor labor.

The "external" information linked to the photograph is provided by the caption, "Road Bed Cut for Trolley, Herkimer County, 1904." Some of the information is straightforward: the gorge was being excavated to provide a roadbed for a trolley in Herkimer County—presumably in New York State because of the source description in the caption, the New York State Historical Association. Checking a historical gazetteer or the Internet

will permit us to confirm this and to learn something more about New York State in the first decade of the twentieth century.

The "internal" information consists of the men's clothing, how they are posed, and the spatial relationships from one to another. The photograph also provides clues to the social relationships between men on different rungs of the status ladder.

The fact that a trolley line was being constructed on land that had not formerly been urbanized—or perhaps lay outside the city limits—offers us visual information about the growth of cities in the United States after 1900. Motorized vehicles had not yet come into wide-spread use (hence the use of the horse-drawn wagon) and workmen still performed labor by hand (there is no evidence of land-moving machinery).

The first "hit" on the Google Internet Search Engine, http://www.rootsweb.com/~nyherkim/, provides some further (and interesting) information. The county was, and continues to be, rural, located in the Adirondack region of central upstate New York. Why, then, did it need a trolley system? Were county officials trying to build a modern city? The photograph does not tell us this, but it offers enough information for us to continue our research.

Several professionally trained historians were shown this photograph, with neither the caption information nor any other hints. They were asked to speculate on what information might be extracted from the scene.

Edmund Abaka, an African-born scholar trained at Toronto's York University, immediately responded in terms of "class, economic activity (mining or road construction and attendant degradation) and transportation." He wondered if one of the workers—barely recognizable in the photographs because he blends in to the background at the left side of the gorge—might appear to be dressed like a Muslim (in turban and with nose and mouth covered.) "Covering the nose alone could be a sign of protection from dust, but the headgear looks like a turban." Abaka added, "The group posed for the picture. Is it designed to extol the virtues of work?"

Donald Spivey, an African-American historian trained at the University of California, Davis, replied:

> "The workers on the hill and those down below seem at risk. The landscape appears unstable. I easily imagine that this is not an operation that cares much about worker safety. The men look to be either Hispanic or recent immigrants to the United States . . . It is also striking that one of the two lighter-complexioned men wears a hat, which indicates status. Definitely a supervisor or boss."

The same photograph was given, without any additional information, to Julia Roa González, a visitor from Venezuela trained in sociology. Here is her reaction:

> "This must be at a temperate climate, perhaps at some elevation. Perhaps the workmen are constructing an access road to a mine. The man with the ledger book is probably English, the project manager or chief of construction. The man in the white shirt is probably a civil engineer."

And finally, Hussein Ablualhassan, a Fulbright scholar from Saudi Arabia, emphasized the layers of sediment unearthed by the excavation, assuming, he said later, that this was the excavation of a "tell," or mound. He offered no comment about the human subjects in the photograph.

What characterizes these different responses is that each individual sees things through their own personal lenses. The historian from Africa guessed that perhaps one of the workers was a Muslim, because the Muslim role in Africa has long been a major theme. The Saudi Arabian worked out of a tradition where history is measured in centuries. The African-American scholar was concerned with ethnicity and class attitudes. The Venezuelan's response reflected the fact that in her country during the last century British firms contracted most public works projects, which was not the case in the United States or Canada.

Photographs, then, are not messages with precise meaning; rather, they provide the raw material for many messages which viewers "see." And since viewers' "see" through the lens of personal cultural values and social expectations, "seeing" and "interpreting" photographs is learned. "Truth," then, varies from eye to eye. The first thing we must do is to determine what is depicted in the image. At that point, the issue becomes less the authenticity or truthfulness of the image and more the role of the photographer (and editor) in presenting it. Photographer Berenice Abbott remarked that the objectivity of the photographer was "not the objectiveness of a machine, but of a sensible human being with the mystery of a personal selection at the heart of it."[5] What is correct and "true" for one person may be completely alien to another.

Some critics still hold to the "pictures speak for themselves" school, which asks the reader to interpret meaning based on personal insight. This is tricky, a kind of unscientific inkblot test, although some scholars have long argued that photographs can be used to construct meaningful historical narratives.[6]

The most pessimistic view about the usefulness of photographic images in research comes out of the theoretical and empirical studies of

sociologists, and of semioticians, who analyze photographs as "extremely complex representations made by the use of conventions."[7] These scholars, including Joel Snyder and Neil Walsh Allen, argue that since photographs are inevitably distorted by the photographic process, and inevitably colored by the photographer's own personal interests, attitudes, and biases, photographs are not realistic.[8] Even some photographers have agreed. Edward Steichen, one of the master photographers of the early twentieth century, contended, "Every photograph is a fake from start to finish."[9]

For our purposes—to learn to use photographs as historical documents—we should reject the pessimistic argument. Clearly, we cannot step back from our own ways of seeing, especially when we examine images that were created to provoke our reaction or to compete as art. But many photographs, without a doubt, provide historical insight, even if that insight is limited to gaining a better sense of how the photographer likely saw things and what contemporaries "saw" when they examined the image or the photograph.

When a photographer, curator, or photo editor nears the final decision on what print to display, offer for sale, or publish, last-minute steps can still be taken to make the image as "perfect" as desired. Whether by darkroom manipulation or by the far easier process of digitizing, skin blemishes can be removed, teeth whitened. A moon can be added to a clear but otherwise empty night sky. Some elements in the photograph can be cropped out, or moved, or shrunk in size. Such actions—if the photographer applies them—move the photographic process ever closer to the process of a painter working on canvas.

We need to consider whether some form of censorship (by civil or religious authorities, or self-censorship) led to one image being selected while others were never printed. Some photographers print a heavy black negative line around their images, a way of asserting that the picture was not cropped, but this technique is easily faked if the photographer is so inclined.[10]

Over time, new technologies made it easier for photographers to capture a broad range of subjects, including subjects under low light and in motion. By the early 1860s, both in the United States and throughout Europe, photographers produced inexpensive images called tintypes. The tintype provided the most typical way for soldiers and families to share images of one another during the Civil War. Tintypes were still being taken by street photographers until the early twentieth century in some parts of the world. They were ultimately replaced by paper-backed films and Polaroid-style instant photography cameras.

Activity

Give cameras—throwaway ones will do—to people representing several groups with different personal perspectives: perhaps recent immigrants or migrants, persons recently on the welfare rolls, retirees, the very elderly, and members of a particular ethnic group. Ask each one to shoot a number of photographs of subjects significant in their lives. Compare and analyze the results. How does each group's batch of photographs differ from the others, and why?

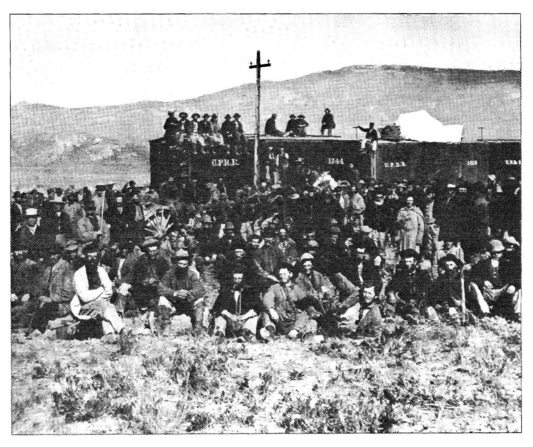

Irish railroad workers take a pause from their labors during the construction of the Union Pacific Railroad in the late nineteenth century.

II

Images from American History

A DIVIDED NATION, 1840–1870

Beginning about 1840, the United States underwent major growth, exemplified by expansion of river transportation, the construction of barge canals, and the establishment of unpaved roads leading into the interior. Via these means, immigrants and other settlers from the coast penetrated what then was a vast frontier. Canal and railroad building attracted large amounts of foreign capital and in turn offered opportunities for jobs. Native Americans, however, were subject to the harsh policy of removal, when eastern Indians were force marched to lands west of the Mississippi. In 1844, Samuel F.B. Morse operated the first telegraph, another American invention that would revolutionize the westward expansion of the United States.

After 1840, cotton continued its hold on the South, and, with the introduction of Eli Whitney's cotton gin in 1793, plantations pushed farther south and west, bringing with them the practice of slave labor. By 1850, 75 percent of all slaves were field hands, most of them engaged in the production of cotton. Antislavery agitation roiled the South; in 1835 a mob in Charlestown burned abolitionist literature. In the North, antislavery sentiment grew, although whites were not friendly to free blacks in their midst. Slavery and race relations became the dominant social theme in the United States during the 1840s and 1850s.

Many excellent URLs on the history of slavery worldwide are maintained by scholarly societies and journals.

See, for example, http://www.spartacus.schoolnet.co.uk/USAslavery.htm that includes accounts from more than two dozen former slaves, including William Wells Brown and Harriet Tubman. Also, see the Website of the *Encyclopedia of USA History* at http://www2.h-net.msu.edu/~slavery/, overseen by Michigan State University.

Social Tension

Fortune seekers poured into California in 1848 and 1849, when reports of the discovery of gold at Sutter's Mill (present day Coloma) reached the outside world. Many men who found jobs in the gold mining area were Chinese immigrants, called "coolies" in local slang. Most had left their wives in China. In this 1852 photograph (see next page), the Caucasian workers, one in particular, look cheerfully at the camera. The four Chinese

men do not look as confident. One stands with hat in hand, staring straight ahead with what appears to be a pipe in his mouth. Is it fair for us to observe that the men seem dour? The photograph separates the two groups of men as if to emphasize the social distance between them.

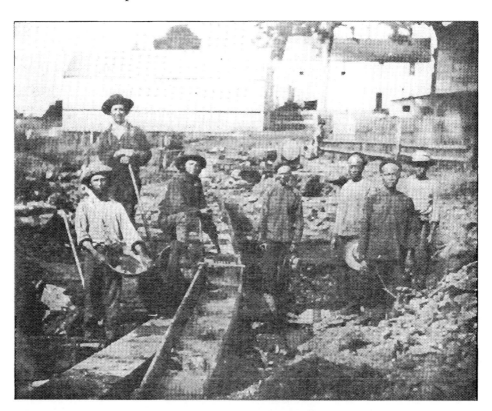

THINK ABOUT THIS

Does the photograph's composition encourage the viewer to examine its subjects as individuals or as groups?

For further study, see: the California gold rush Websites at http://www.museumca.org/goldrush, or www.goldrush1849.com

Slavery and Abolition

Photographs of enslaved men and women at work are rare; here an overseer on horseback watches slaves toiling in a southern cotton field.

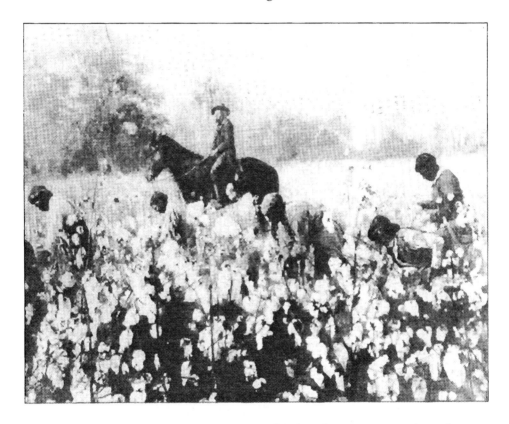

Abolitionists used photography to further their cause against slavery. One little-known fact is the practice by northern abolitionists of bringing slaves from the South on tour in the North. For shock value, they included children with complexions so light that audiences refused to believe that they had been born into slavery.

The Oberlin Rescuers, a group of abolitionists, who were part of the Underground Railway are shown in the photo on the next page standing outside the Cayahoga County, Ohio, jail. They had just rescued a fugitive slave named John Price.

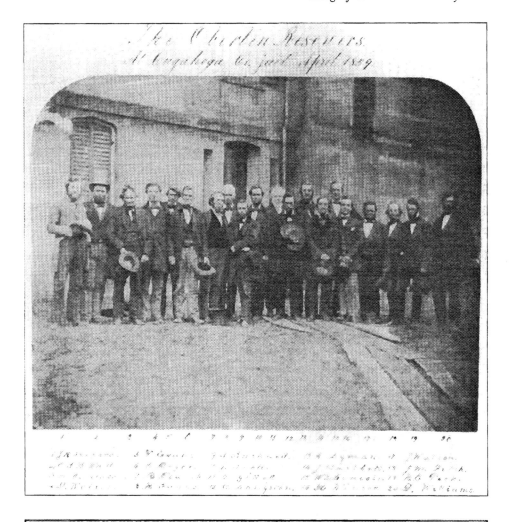

For further study, see:
http://lcweb.loc.gov/exhibits/african/afam005.html, from the African-American Mosaic project of the Library of Congress.

Photography, of course, made it possible to document the institution of slavery in the United States during the two-and-a-half decades before abolition in 1865. This posed portrait of a group of African Americans offers no direct clues about the identities of its subjects. The men, women, and children present a variety of postures, ranging from the woman on the left, holding what appears to be a bowl; the woman seated on the right side of the bench seems exhausted or dazed. The children acknowledge the presence of the camera and the two men look directly at it. One of them is smiling, his hand almost touching the dog sitting by his feet, the other seated man has a cigar in his mouth. The gazes in the photograph are non-reciprocal, emphasizing its posed quality.

What we know from the caption supplied with on the photograph is that the woman on the left is Harriet Tubman, who escaped from slavery in Maryland in 1849 and who returned 19 times to free almost 300 other slaves as part of what has been named the "Underground Railroad." The subjects of this photograph were all rescued by Harriet Tubman during earlier trips.

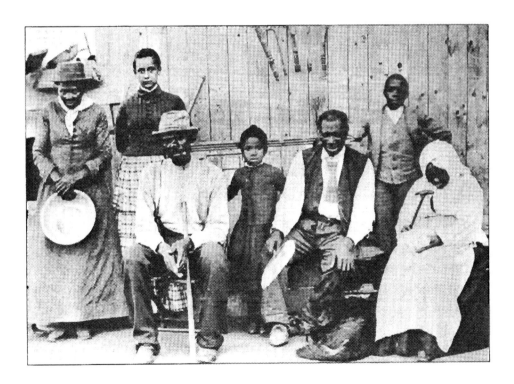

The Civil War

Photographer Mathew B. Brady emerged from the American Civil War as one of its greatest chroniclers, although recent research has demonstrated that some of his scenes were staged, some to the extent that his assistants posed live soldiers as "dead" and also moved corpses from where they lay. But his photographs brought the scope of the war to the population at large.

THINK ABOUT THIS

Was the seated man aware of the presence of the camera? How would the picture have differed if this had been the case?

Children

Children were employed in dangerous work on both sides of the Civil War. Here Brady photographed a "powder monkey," a child put to work on the deck of an explosives-carrying ship.

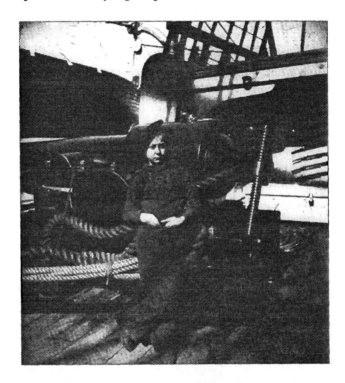

For further study, see: http://docsouth.unc.edu

Photographs brought the horrors of war to the public at large. Here a starved and naked former federal prisoner sits in 1864, after being returned to Annapolis.

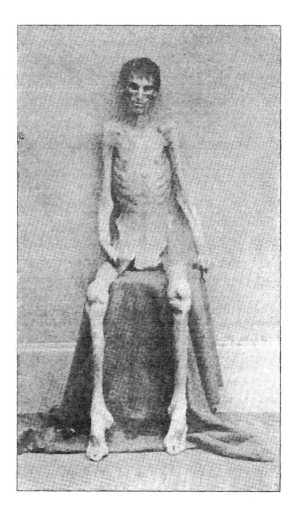

THINK ABOUT THIS

Theorists of visual anthropology assert that the camera gaze can establish the illusion of intimacy or communication. Was this the case here, in this horrifying photograph?

For further study, see: http://sunsite.utk.edu/civil-war/

A Nation Under Reconstruction

This photograph of Richmond, the Confederate capital, smoldering in ruins after being burned by Union cavalry troops in early April, 1865, illustrates the tragedy of the American Civil War, which in Union states was called the "War of the Southern Rebellion." Over 600,000 Americans died in this war, twice the number of Americans killed in World War II. Compare the burned-out shells of buildings with the picture of the aftermath of the San Francisco earthquake in the preface. The Richmond photo has horses tethered in line along the iron fence in the bottom portion which lends an air of calm; interestingly, the photographer included no human figures in the scene. Smoke rising from the burning city may recall another image etched into the minds of Americans today: lower Manhattan in the aftermath of the September 11, 2001, terrorist attacks.

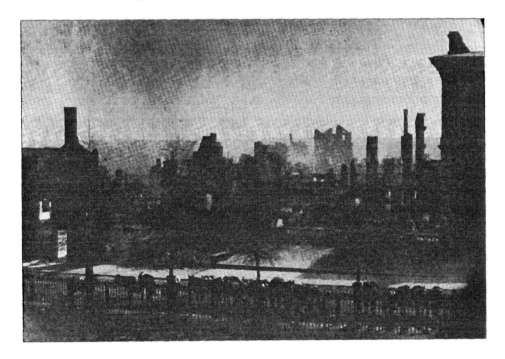

The North's victory in the Civil War notwithstanding, at the beginning of the twentieth century, many educated whites supported the implementation of Jim Crow laws mandating racial segregation in the South. They considered blacks to be genetically, therefore permanently, inferior to whites. Blacks were, they argued, hedonistic children, irresponsible, and

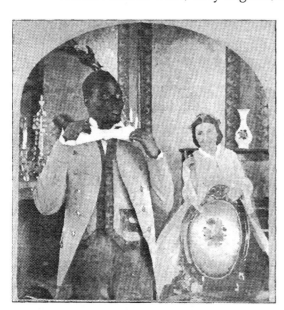

left to their own devices, destined for idleness—or worse. Whites ridiculed blacks with derogatory names. They were described as superstitious, happy-go-lucky, and lazy. Consider this circa 1860 posed photograph, titled "The Darkey's Vanity." It offends us because the black man is shown leering, childlike, and a white woman is looking at him in a suggestive manner forbidden by society. The man is dressed in livery, and made to seem childlike and "happy-go-lucky" as in the typical stereotype.

THINK ABOUT THIS

Why didn't whites see through the stereotypes and protest the hurtful depiction of African Americans? How can we understand this insensitivity given the strength of religious beliefs in nineteenth- and twentieth-century America?

Activity

Go through a source of historical photographs (an archive, a historical society, a private collection, published books or magazines) and find other groups who were stereotyped in photographs. Analyze how this was accomplished. Were the photographs taken at odd angles? Using unusual lighting? Using what may have been distorting lenses?

INDUSTRIALIZING AMERICA, 1870–1900

The quality of life for many Americans improved dramatically during the decades between 1870 and 1900, in part as a result of continued industrial growth and gains in transportation, which gave jobs to recent immigrants. But there was a downside.

The decades after the 1870s brought terrible depredation to Native American peoples, who often fought back against whites. Former slaves, emancipated in the 1860s, sometimes had no way to obtain work or shelter. Labor conditions in the mines of the West—one of the best employment opportunities for whites—had conditions that were terribly dangerous. This led to efforts to organize unions, and thereafter to labor violence. Westward expansion saw such groups as the Mormons flee persecution in the East and Midwest. Mexican Americans received terrible treatment in the Southwest, where they came in search of employment.

The massacre of the Lakota Sioux at Wounded Knee, in 1890, marked a new kind of transitional period in relations between Native Americans and whites. On the prairie, cattle ranchers battled wheat farmers, and cowboys who rode the range often were protected only by vigilante justice. Violence was frequent in cities and towns of the west, and as many as 50,000 women worked as prostitutes west of the Mississippi.

The last decades of the nineteenth century, during which hand labor on farms competed with machine labor in factories, and agricultural workers labored from dawn to dusk, did not produce much prosperity. Many of the advancements that were made crashed in the Great Depression of 1893–97. By the 1890s, Reconstruction and westward growth had spurred the enlargement of the bureaucratic powers of the United States government, especially in such agencies as the Department of the Interior and the Interstate Commerce Commission (1887). But in 1891, a social critic complained that industrial society had become a "wretched failure" to "the great mass of mankind."

Photographs document the survival of old ways and the rise of new ones. We know that generations of slavery in the American South left a deep legacy of complex relations between the races. On one side, hostility towards African Americans led to the emergence of racist "Jim Crow" barriers, formally institutionalizing racial segregation. On the other, members of the white elite employed former enslaved persons in domestic service, entrusting them with nurturing their own children.

Posed Subjects

THINK ABOUT THIS

The philosopher and critic Walter Benjamin wrote that photographic portraits served as a "cult of remembrance," a means literally to preserve the past. Others have argued that portraits mislead, that they are posed to give an impression desired by the photographer. But is this necessarily wrong?

Still portraiture has long provided a cultural index of how society teaches people to regard themselves. In photography's early days, people sitting for their picture faced the camera stiffly, without apparent emotion. Having one's portrait taken was a chore, a way of remembering. Many early portraits were taken with the subject maintaining a stern visage.

But during the late nineteenth century, people who sat for portraits paid more attention to the way they looked. Photographers offered an array of devices to improve appearance, including retouching.

As time passed, some professional photographers sensed that their customers could enjoy a joke. Here is a front-and-back portrait of a young man.

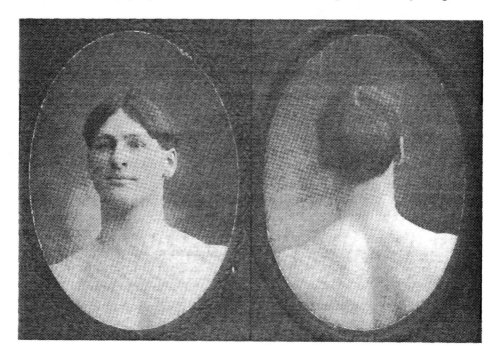

Native Americans

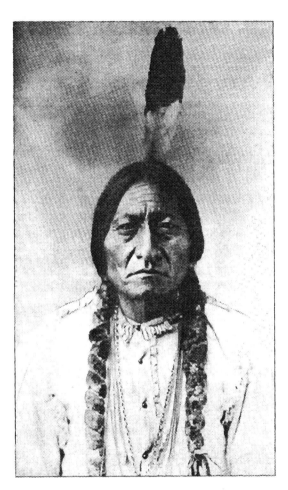

Photographers produced endless quantities of photographs of Native Americans, because the public considered them exotic. This circa 1882 portrait of Sioux Chief Sitting Bull shows him in what may have been a more authentic costume than he was usually asked to wear.

This photograph seems even more authentic. Here, he sits with his family, including his ninth wife, three of whose six children are depicted.

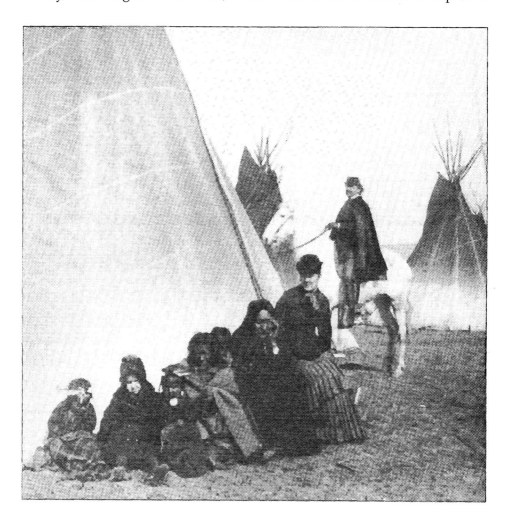

THINK ABOUT THIS

The caption says that Sitting Bull is with his "squaw," a term considered derogatory today. To what extent, if any, should a contemporary description or caption be judged improperly worded by modern standards?

For further study, see: http://home.epix.net/~landis/arrival.html on the Carlisle Indian School, and the Oyate site, with some interesting photographs of Native Americans today, at http://www.oyate.org

Photographers glamorized the lore of cowboys and Indians as a stock in trade. Here is another example:

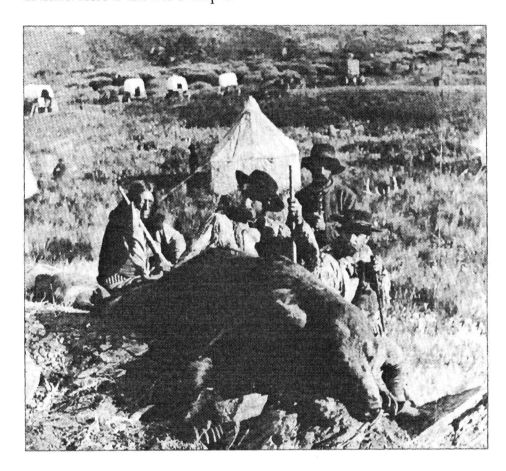

The photograph, dating from the 1850s, shows George Custer (later a Civil War general who was killed at the Battle of the Little Bighorn) crouching beside a dead bear, holding his rifle after a hunting expedition. The men with him are identified as "white scouts and Native American guides." What in this description or in the way the photograph was posed reveals attitudes of the time towards the western United States?

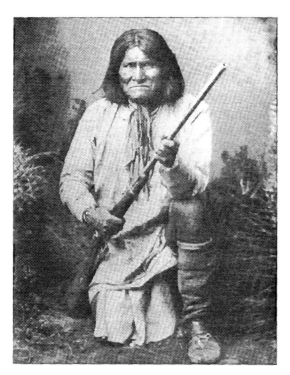

Geronimo was photographed many times in many ways, revealing, in the words of Holland Cotter, the "elasticity of photographic 'truth.'"[11] Some photographs portrayed him as a scowling warrior, rifle in hand. Others depicted him as the ideal of the noble savage. Others, less seen publicly, showed him among members of his family, an ordinary father and grandfather. Geronimo, Cotter notes, was content to play all of these roles. Aware of the power of the photograph, toward the end of his life the former guerrilla leader made a living by selling autographed portraits of himself.

THINK ABOUT THIS

What does the presence of a painted backdrop add to this photograph?

For further study, see: Geronimo's history at
http://odur.let.rug.nl/~usa/B/geronimo/geronixx

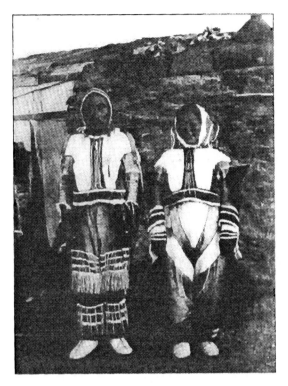

Less contrived photographs of native peoples were taken during the 1890s by naturalists and scientists seeking to record natives in their habitats. Here, a pair of Alaskan Inuits pose in clothing made of pelts.

Other Subjects

Americans west of the Mississippi River were subject to raids and depredation not only by hostile Native Americans but also by white "desperados," gangs headed by men like Jesse James and Cole and Jim Younger, who rode the West committing robberies and other crimes. Eventually, they became part of the folklore of the American West. During this decade, the James-Younger gang, shown on the next page, earned notoriety for their daring as outlaws. In later decades they were romanticized as a kind of American Robin Hood saga.

THINK ABOUT THIS

Why did outlaws like those on page 39, and later Bonnie and Clyde, seem to relish posing for photographers? Here they pose with rifles, pistols, ammunition belts, hats, and spats.

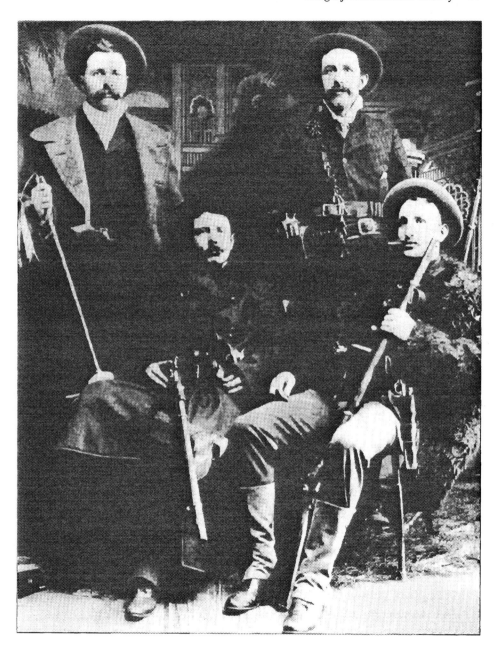

For further study, see: http://www.ci.st-joseph.mo.us/jesjames.html

In rural parts of the United States, agricultural methods changed hardly at all over the decades. Here, children working in a cotton field in Mississippi collect cotton bolls.

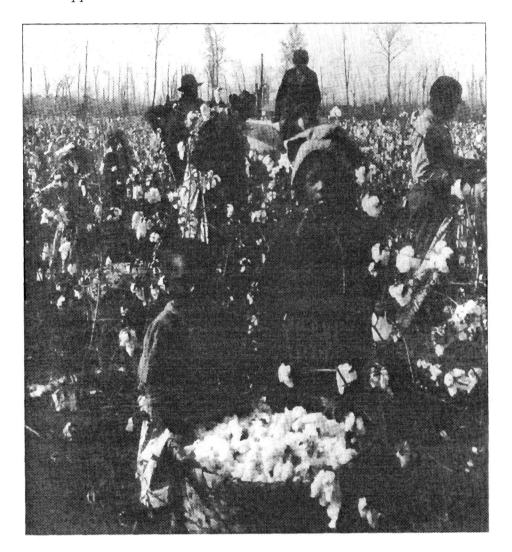

Some photographs were real enough. This hunter, Ralph Morrison, was found dead by federal soldiers after having been scalped, presumably by Native Americans on whose territory he had been trespassing. American magazines such as *Harper's* frequently published wood or steel engravings made from photographs of frontier atrocities, including some during the 1870s showing naked victims scalped and with body parts mutilated.

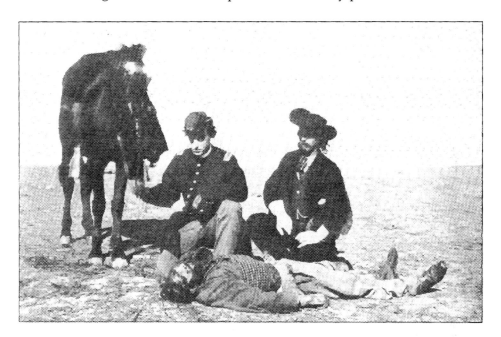

THINK ABOUT THIS

How did society draw the line between images it wanted to see (or which titillated the imagination) and those it considered indecorous? How did editors likely decide what images to publish and not to publish?

For further study, see:
http://www.earlyamerica.com/review/1998/scalping.html on the often-violent interaction between Native Americans and whites on the frontier. http://www.ala.org/West/programming.html deals with the West and the frontier in American culture.

By the end of the 1870s, life in the United States, especially in the East, South, Far West and Midwest, achieved many of the appearances of today. Children attended school, men went to work, although women usually did not. The achievement of relative affluence for most urban and small town Americans permitted leisure time activities when work was not required.

Everyday Life

To modern eyes, this waterfront scene with row after row of burlap-wrapped piles does not convey any sense of dynamism. The steamboats lining the docks were waiting to load bales of cotton, the United States' major export and the staple crop of the American South. The photograph hints at the mechanical processes beginning to substitute for human labor. There are three large cranes at wharf side; a man, presumably the operator, stands next to one crane. An observer of the same scene a decade earlier would have likely seen large numbers of stevedores, horses, or mules and no machinery.

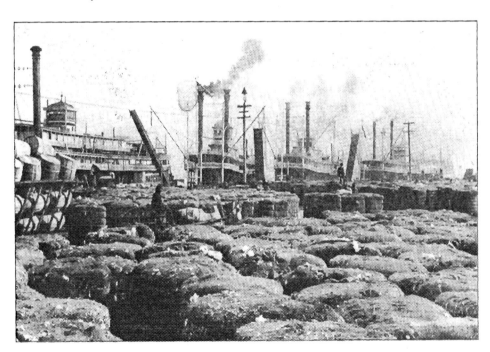

By the new century, Americans from the more affluent classes had abundant time for leisure. College athletic teams, made up of student players (with occasional "ringers," or non-students as well) competed. Here, Cornell University and the University of Rochester compete in a football scrimmage in 1889, before a throng of standing spectators lining the open grassy field. Does the photograph show women in the audience?

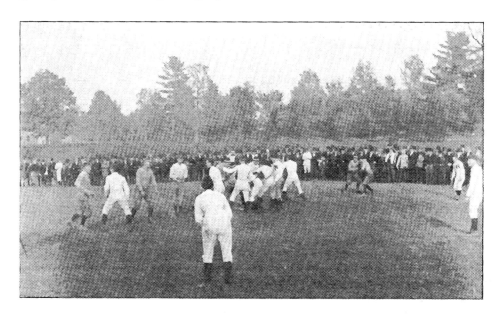

For further study, see:
http://www.press.jhu.edu/press/books/titles/sampler/watterson.htm, on the origins of big-time college football.

Here is a boardwalk scene from Asbury Park, New Jersey during the 1880s.

By now, working Americans had enough spare time to spend on sports and personal pleasures. In rural parts of the country, men and women traditionally worked without cease. In small towns and cities, most people had Saturdays free; Sundays were reserved for attending church and not considered a proper day for leisure.

Economic Depression

The economic depression of the early 1890s took a terrible toll on working-class families. The nation's major railroads declared bankruptcy in 1893, ending two decades of business prosperity. More than 150 banks and 15,000 businesses closed. Unemployment reached 25 percent in many cities. On Easter Sunday 1894, a labor leader named Jacob Sechler Coxey organized a huge army of the unemployed to march on Washington, D.C., to demand relief. He called his marchers the "Commonwealth of Christ Army." Several hundred set out with Coxey from Massillon, Ohio, and

were joined by other groups from Boston, Denver, Salt Lake City, Reno, and Omaha.

This photograph shows the marchers, carrying a large American flag, en route to the nation's capital. But Attorney General Richard C. Only, a former lawyer for the railroad companies, arranged with local officials to impede the marchers. Only 600 reached Washington with Coxey, only to be clubbed by police and then arrested for trespassing on government land. The phrase "Coxey's Army" entered American popular culture, not as a symbol for workers' rights, but as a synonym for a motley, bedraggled assortment of men. The social climate during the 1890s did not extend respect to protesters.

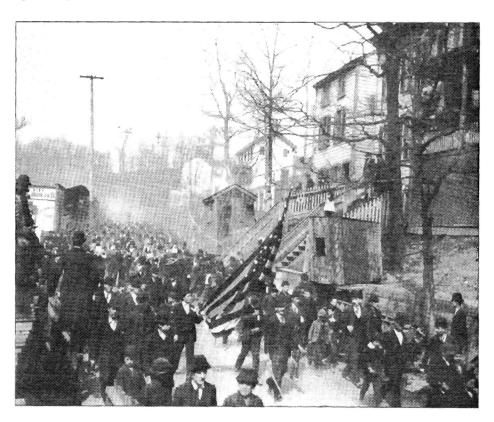

THINK ABOUT THIS

How do the children accompanying the marchers appear (see photo on previous page)? How are the adult marchers dressed? What might this say about poverty in the industrializing United States? What observations might be made about the buildings being passed by the marchers? What does the presence of a telegraph pole suggest? What might the small wooden structures near ground level be?

Immigrants did not have it easy, but former slaves often had nowhere to go after emancipation. This photo documents exslaves crowded outdoors in a South Carolina coastal city.

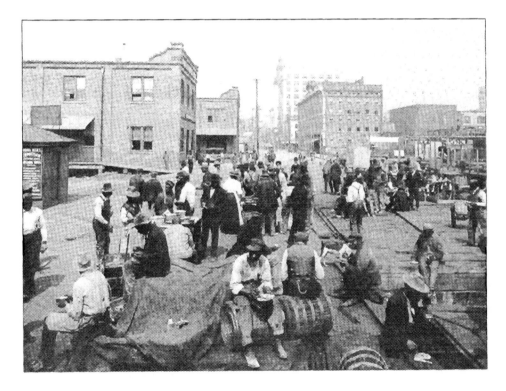

African Americans

Whites continued to disparage African American culture and to belittle it. Here, eight men from Black River Falls, Wisconsin, pose dressed as minstrels for a community entertainment in the 1890s.

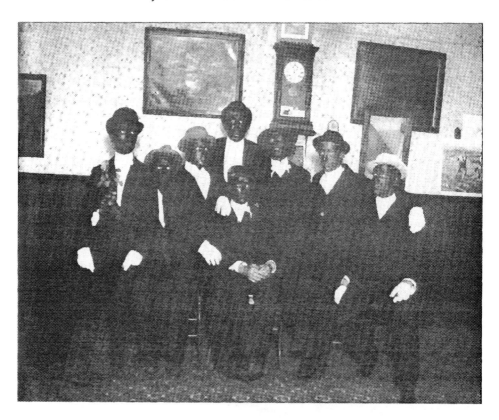

THINK ABOUT THIS

What attitudes led American whites to think that behaviors mocking the appearance of African Americans were humorous?

Children and Youths

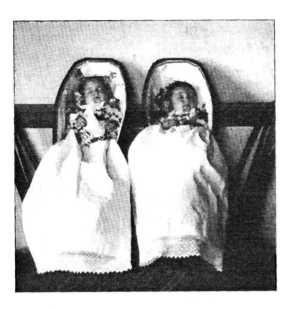

The prevalence of endemic disease, the lack of public sanitation facilities, and rudimentary knowledge of medicine resulted in high rates of infant mortality. Families whose children had died often dressed their dead children as angels or simply hired a professional photographer to make one final visual record for the family to keep as a remembrance. Recently deceased adults were photographed as well.

In the lower photograph two perfectly healthy Inuit infants lie side by side, wrapped to keep them warm, but when we look at this pair in comparison to the set above, we receive a visual jolt.

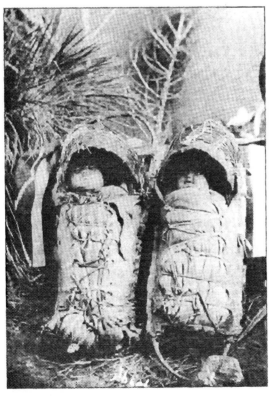

Small town life revolved around hotels and churches. In this photo, the owner of a hotel in Black River Falls, Wisconsin, the seated woman in a white blouse, hosts a gathering of others—a man not related to her and three youths, standing behind her, one of whom is dressed in overalls commonly worn for farm work.

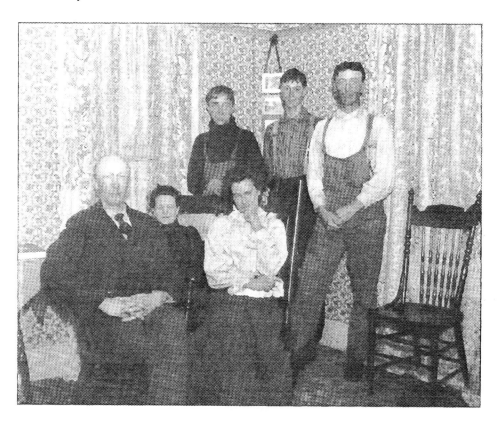

Racial integration rarely occurred, although it is occasionally documented photographically. Here is a photograph of the baseball team from the Battleship *Maine*, showing one black team member. William Lambert, at top right, was the star pitcher. All of the members of the team died when the ship blew up in Havana harbor in February 1898. A year earlier, the team had won the Navy baseball championship.

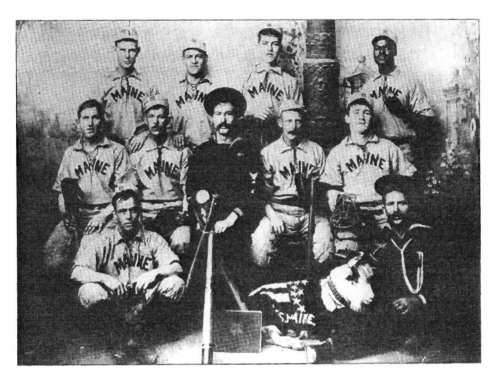

Business and Labor

The earliest industrial laborers in America were women. They were excluded from guilds and labor unions and therefore had no one to speak up for them. Here, women work in a Paterson, New Jersey, silk mill.

Women performed much of the industrial labor in the United States from the turn of the century, along with children, especially girls whose small dexterous hands made them ideal for work in the textile mills of the South.

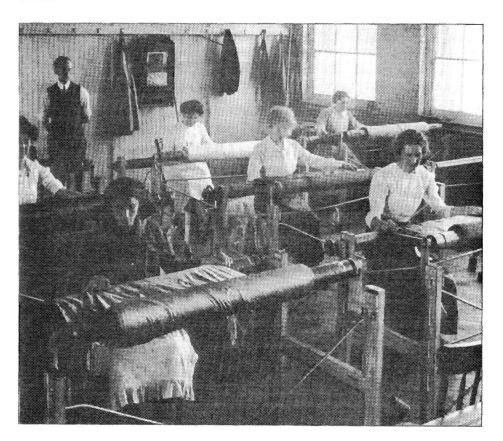

Child labor was a serious issue that emerged along with the industrial revolution. Here, an image from the National Archives and Records Administration in Washington, D.C. shows solemn young child laborers in 1908 posing at the Catawba Cotton Mill in Newton, North Carolina. The mustachioed boss stands to the upper right behind the boys who appear to be eight years old or younger.

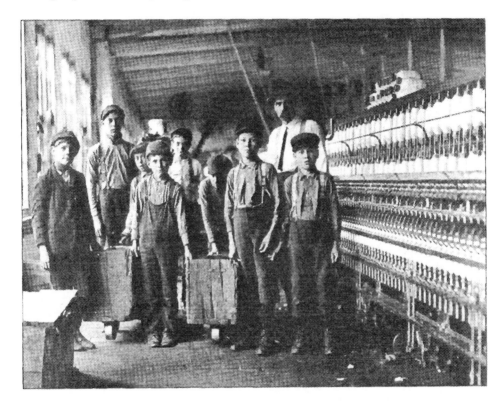

Industrial work was often filthy as well as dangerous. Here, two grimy coal miners wearing lantern hats to allow them to see in the dark push a heavy coal cart uphill along a track through a narrow dark shaft. Thick timbers brace the low ceiling of the mine.

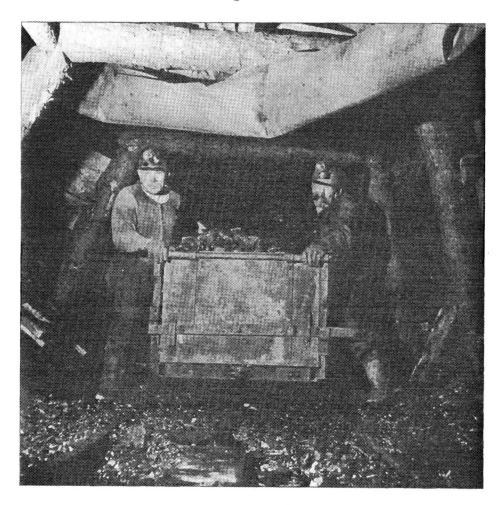

School rooms, where almost all of the teachers were unmarried women, represented another kind of workplace for Americans.

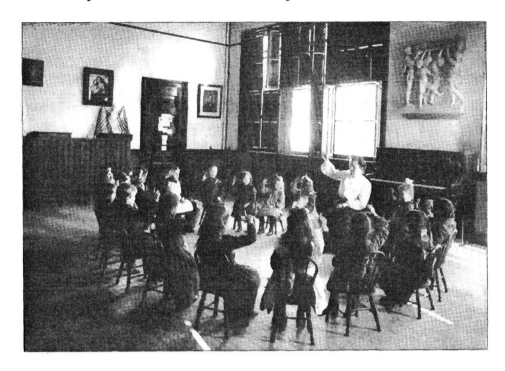

For further study, see the Website on the history of American education at http://www.nd.edu/~rbarger/www7

Many communities, especially in the Deep South, rented out convicts to private entrepreneurs to carry out field labor or work on public works. This 1892 chain gang of prisoners in Asheville, North Carolina was put to work building or repairing railroad track.

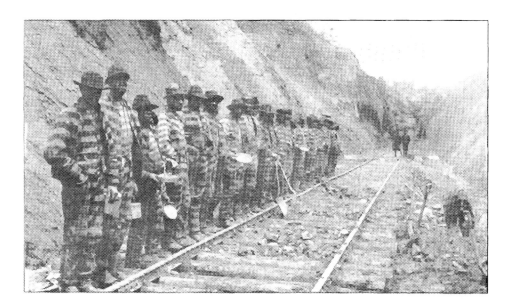

The men, who seem to be arranged by height, toe the track they have just worked on, their line stretching almost to the end of the horizon. Some hold shovels or pails, and a shovel is dug into the ground across the track. Two men, presumably armed guards, stand at the point where the tracks disappear from our view. The photograph seems less like western North Carolina, where it was taken, than like the Rockies or the Andes. The men wear felt-like hats on their heads, and wear shackles on their ankles, as was the custom with prison road gangs.

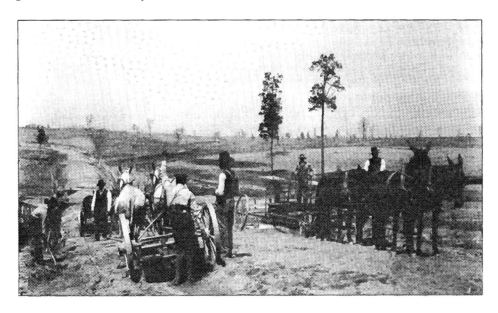

Roads were built manually by men using plows, horse teams, and wagons. Here, African American laborers hew a road through rural Alabama during the construction of the Tuskegee Institute.

Activity

Local and State historical societies often contain a wealth of photographs in their collections. Focus on the period covered in this chapter (1870s and 1890s) and search for photographs that illustrate aspects of historical change that one would not expect to find reproduced in history books. Are there photographs, say, showing regular interaction between members of different racial and ethnic groups? Among members of different social classes?

NATION OF IMMIGRANTS, 1900–1920

The turn of the century produced the first systematic movements for urban reform in America, aided substantially by a small group of photographers whose work is described in the following sections. But elsewhere in the country, civil rights and equal treatment before the law continued to be denied to African Americans. The southern Populist movement, initially a promise for religious tolerance, abruptly became an advocate of racism. Americans crowed over the seemingly easy victory over Spain that

brought Cuba, Puerto Rico, and the Philippines under the United States flag. Southern progressivism, to some extent, resisted the strengthening of segregationist laws, and immigrants flooded into the country.

The decade beginning with 1910 saw labor conflict, small starts for movements fighting for the rights of women and also of blacks, and the coming of a wave of patriotism as Americans prepared for entry into World War I. The war, of course, overshadowed all aspects of American life. Patriotism in turn stirred anti-German feeling, as exemplified by acts of intimidation against German Americans. But by 1920, the nation seemed on the way to "normalcy."

Advocating for Social Reform

In the early 1900s, documentary photographer Richard Hoe Lawrence produced a series of photographs of slums in New York's Lower East Side that were used by reformers to press for urban renewal. The name of the series, "Scenes in the Lower East Side Slums. Bandits' Roost, 59 1/2 Mulberry Street, New York," testifies to the photographer's intent (see next page). The man at front right leans on what at first appears to be a rifle but what more probably is a crutch or wooden support. Men and women stand on wooden steps and on a ledge, the man in a hat seated on the right side of the photograph dangles a cigarette from his mouth and stares. Children appear in different places, the alleyway is filled with hanging laundry, adding to the sense that women were always working. Two overflowing refuse cans stand at the entry to the alley on the left, and a mound of dirt sits in the middle of the otherwise paved courtyard.

THINK ABOUT THIS

Why do the men and women in Bandits' Roost appear content, some of them smiling at the camera? From where does our cultural instinct to do so come? Do you think that the residents of the tenements straddling this alley realized how bad their living conditions were, or are we shocked because of what we know today about such diseases as tuberculosis and dysentery, spread in conditions such as those depicted here? How might a photograph taken in a low-income neighborhood in an inner city today differ?

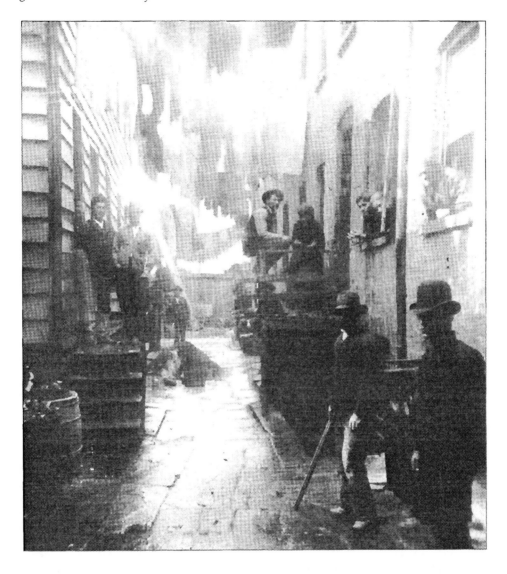

The dramatic photographs of urban slums taken at the end of the century and into the new one—by Lewis Hine, Jacob Riis (initially, a reporter covering crime), Richard Hoe Lawrence, Lawrence Veiller, and others—are useful to us as long as we understand their origins. Riis, a Danish immigrant, used his camera to capture the harsh life of immigrants in New York City tenements. Hine, born in Wisconsin, was a self-taught photographer drawn to the downtrodden. Trained as a sociologist, he photographed miners and factory workers to expose examples of child labor, unhealthy work conditions, and grinding poverty.

This photograph was one in a famous series by Hine of young girls employed in textile mills across the South.

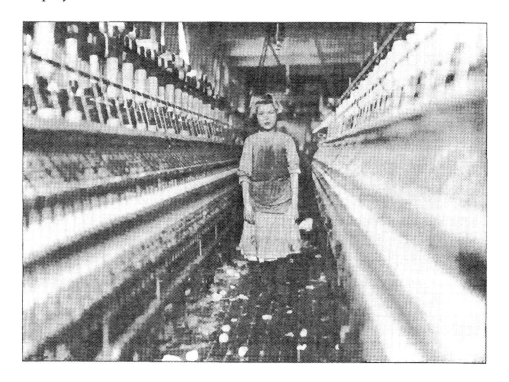

A second image captures a boy working in a similar facility.

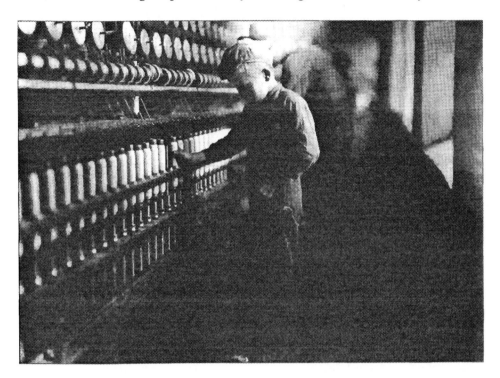

These photographs are significant not only because they led to protective labor legislation but also because they demonstrate how American life during that time was defined by the existence of a *cordon sanitaire*, a clean wall of law, custom, and precepts that isolated the poor from the more fortunate. Most affluent people learned about living conditions among the poor not from first-hand experience—for they learned how not to look even when they saw poverty around them—but second-hand, from reading the moralistic exposés of the time and from viewing illustrations of poverty. As a result, viewers of the reformist photographs were "pre-programmed" to see the poor as morally and biologically inferior.[12]

For further research, see:
http://mohawk.k12.ny.us/progressive/ on the social reform movement, and the Website of New York's Lower East Side Tenement Museum at http://www.tenement.org/ This site offers many interesting online photos of tenement life, including a virtual tour of a tenement on New York's Lower East Side.

During the decade from 1900–1910, hundreds of thousands of immigrants came to the United States, often entering through Castle Garden in lower Manhattan or via Ellis Island. In 1907, the number of immigrants slated to be processed through Ellis Island was fixed at 5000 each day. On one day in Spring 1907, more than 15,000 passed through Ellis Island and were transported to Manhattan. Photographers captured the new arrivals in their foreign clothing seeking, probably, to depict how different they looked in contrast to more assimilated earlier arrivals.

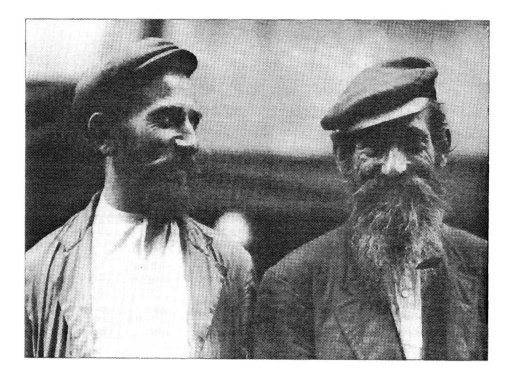

This photograph captures a group of new arrivals aboard ship.

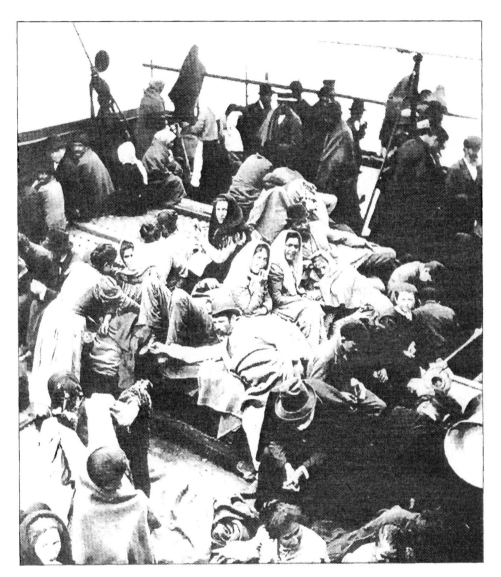

Immigrant Culture

In the early years of the twentieth century, immigrants from Europe and elsewhere, once they gained employment, sent money home to their families, either to pay the passage of siblings or other family members, or to pay

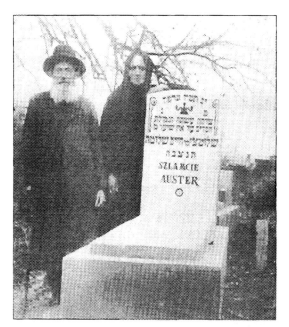

for burial costs when a parent or other relative died. Since a mailed written receipt did not guarantee that a tombstone had actually been made, a photograph of the gravesite was taken and sent to America as documentary proof. This tombstone is inscribed in Yiddish, the language of Eastern European Jews, but the name of the deceased is written in English.

Below is an interesting photograph of a group of elementary school children in Boston circa 1919. What captures our attention is the fact that the classroom is fully integrated, racially as well as by gender. Should we be surprised by this?

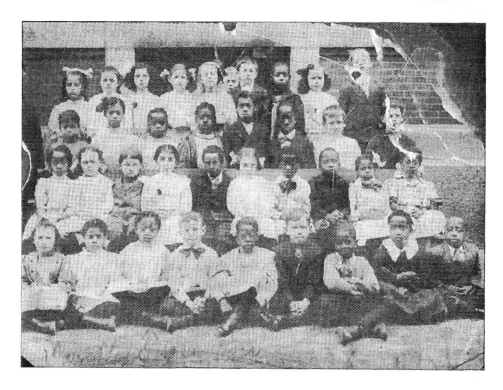

Everyday Life

Like the photographs of Mathew Brady, however, we now know that some of the early photographs of the urban poor were staged or manipulated to sway viewers to reformist goals. Recent studies have demonstrated the great extent to which these images were false; yet the basic grit of city life was real enough. The photographs of Riis and his fellow reformers were taken to exemplify photography's claim to realism.[13]

In contrast, at the time of the first World War photographers turned their attention to cityscapes out of a totally different motivation. Tired of studio work, which had grown sterile, they embraced the vitality of the streets, the land, and the bustle of daily life. Modern cameras and faster films allowed them to capture scenes much more readily than before, with the result that this generation of photographs was more spontaneous, with less attention given to posing subjects.

Work

Hine also photographed workers, especially immigrants, such as this portrait of mustachioed men standing outside a Russian boarding house in Homestead, Pennsylvania, in 1909.

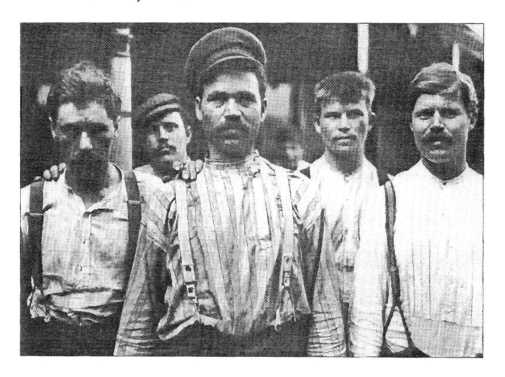

Mining company executives from Pennsylvania and Ohio and throughout the South, preferred to hire adolescent boys since they worked for miniscule wages and, because of their slight frames, they could work in the farthest reaches of the underground tunnels. They performed identical labor to grown men and suffered the same dangers of mine work such as black lung disease and tuberculosis. This photograph was taken at a Pennsylvania coal mine.

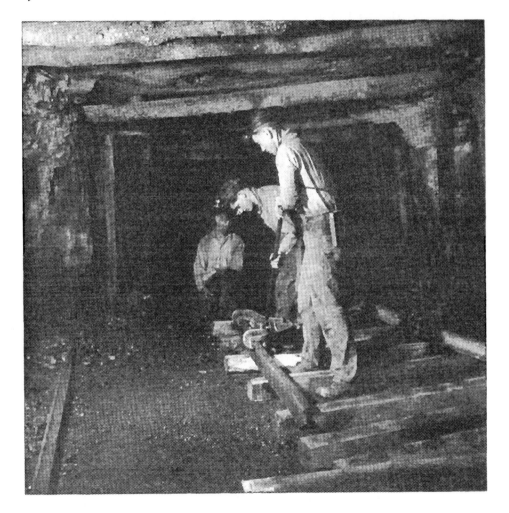

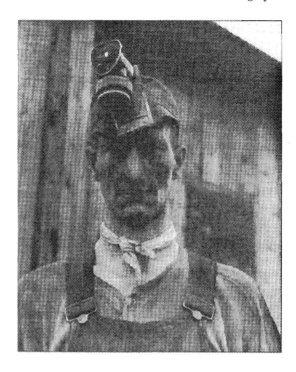

Consider, in contrast, the hardened, grime-caked face of an adult miner, with his head lantern.

For further study, see:

http://www.historyplace.com/unitedstates/childlabor/

This is an exceptional collection of photographs by Lewis Hine taken in factories across the United States from 1908 through 1912. The National Archives Website at http://www.archives.gov/ also provides images from Lewis Hine.

Minorities

This photograph of a Seminole Indian of the Miccosoukee tribe in the South Florida Everglades was taken in the early 1900s. At close look, the man's color seems to be similar to that of an African American. In fact, many slaves fled from the Deep South to Florida, seeking refuge among Indians and intermarrying.

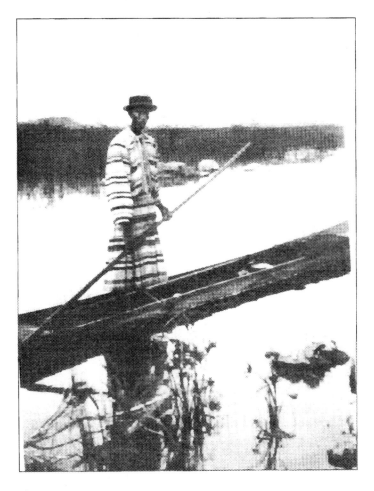

For further study, see:
http://www.fooshotkee.com/member_state_tribe.htm

African Americans badly lagged in material comfort. Consider this family in front of their wooden shack on the grounds of the South Carolina plantation where they had formerly been enslaved.

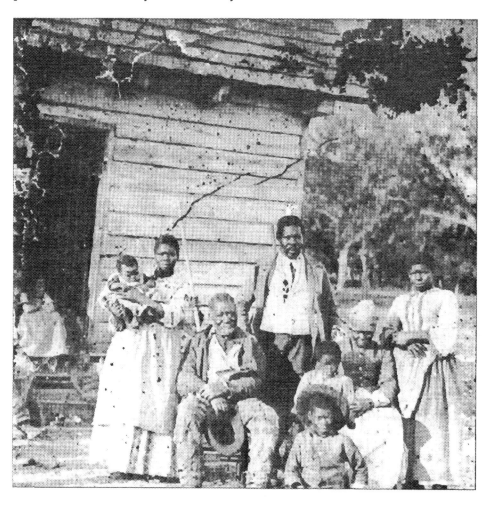

Few black Americans could hope to attend college or university before 1910. The most notable exception was Dr. Booker T. Washington's Tuskegee Institution in Alabama. The institute not only instructed pupils in college-level subjects but also prepared them for careers in medicine, law, architecture, and education. This photograph, dated circa 1905, is captioned "Instructor and Three Graduates with Diplomas."

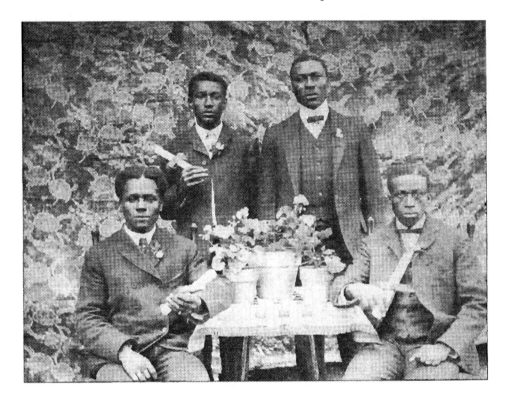

THINK ABOUT THIS

What does the composition of the photograph suggest about the intention of the photographer? What does the body language of the three graduates holding their rolled up diplomas suggest? What is the effect of the potted plants, of the flowery cloth backdrop? How are the four subjects in this photographs dressed? What reactions might viewers have had seeing copies of this photograph?

American Confidence

By the turn of the century, architects and developers were turning to steel frames in the construction of dramatic new high-rise buildings. Here, New York's Flatiron office tower, built in the Chicago Early Modern Style in 1902, fills an odd pie-shaped slice of land at the corner of Broadway and Fifth Avenue. Photographer Alfred Steiglitz, who often photographed it, said that "it's like the bow of a monster ocean steamer—a picture of the new America still in the making."

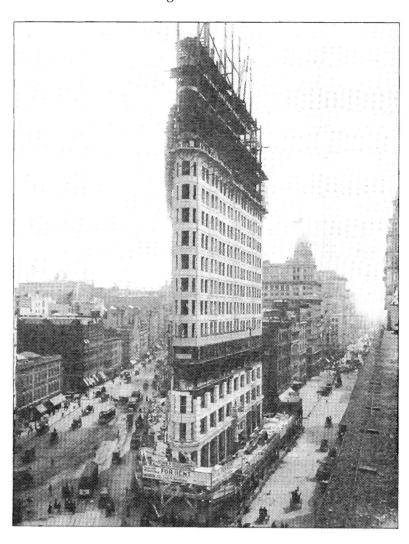

Consider this Philadelphia street scene from about this same period.

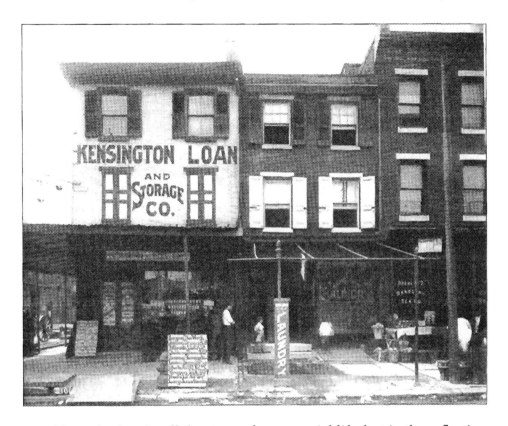

Not only does it tell the story of commercial life, but in the reflection on the window of the building at the left, one can see the receding lines of telephone wires strung from wooden poles. The store at the left of the photograph is a pawnshop. Most city dwellers had no access to bank credit, and many had to pawn family heirlooms or work tools (sewing machines, musical instruments, even fountain pens), leaving them as collateral in exchange for cash, to be redeemed later when the loan (and interest) was repaid. There is a small sign reading "MONEY ADVANCED ON ALL ARTICLES OF VALUE." The pawnshop also sells jewelry, including "diamond rings" for $3.

The adjacent laundry, run by a person or family with the Chinese name of Hong Wah, also sells items of clothing, including children's shoes for 35 cents and ladies' shoes for 35 cents and up. The Randolph Tea Company sells fresh fruits and vegetables as well, which are displayed in front of the store.

The people in the scene—that likely dates from the first decade of the twentieth century (a fact than can be corroborated by checking newspapers for prices in Philadelphia during various years)—seem well dressed, either wearing suits, or, in the case of the man and two children at center, clean white shirts. The sidewalk is relatively clean but debris, mostly wrappings, litter the gutter.

Technological advances changed the quality of life for all but the poorest Americans by 1900. Cities managed to handle sewage, improved their water supply, introduced street lighting, and built skyscrapers. Large cities constructed modern means of public transportation. In the country-side technology came more slowly. Examine this image of a biplane soaring above the heads of a horse and rider.

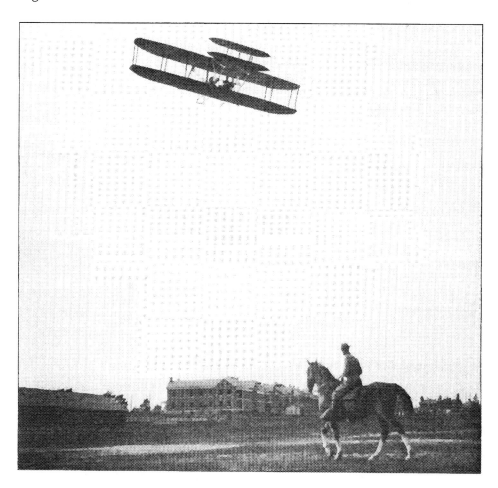

THINK ABOUT THIS

How might contemporary viewers have reacted to the photographic image on page 73? Does the fact that the horse is mounted by a rider change how we look at the image?

Photographers teased the imaginations of patrons by using special techniques to create unique images to sell as postcards, the major form of communication during the early years of the twentieth century. Consider this 1910 postcard satirizing the impact of science on agriculture, and showing huge crops, including an enormous potato behind the car, the image titled "The Modern Farmer."

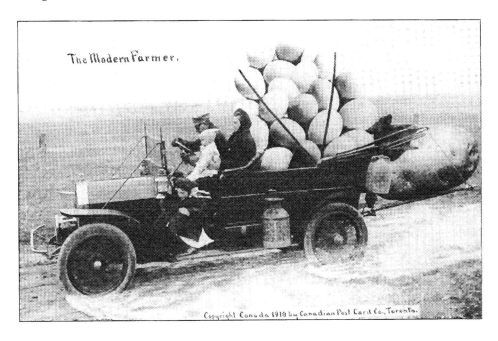

Economic Life

Outlets for photographs enjoyed publishing evidence of American agricultural affluence—amber waves of grain, and so on. Here, penned in cows wait, possibly for slaughter.

By this time, social critics began to condemn working conditions and the unsanitary environments in which products for public consumption were prepared. The photograph on page 76 of a Chicago meat packing plant suggests to us conditions that may well have been lacking in sanitation and that may have been detrimental to the long-range health of the workers, who wear neither gloves nor protection on their heads.

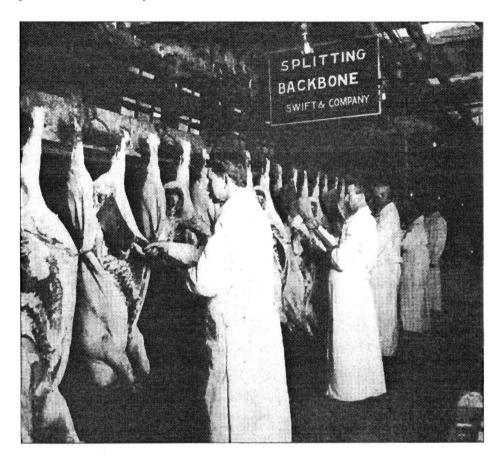

For further study, see: http://www.swiftbrands.com. This site provides a history of Swift & Company, a long-time meat packing firm.

Racism

Remember that in 1865 the forces of the Union won a crushing victory against the Confederacy, followed by a generation of political occupation under Reconstruction. When this ended, the South underwent cycles of terrorist violence, by lynching mobs, the Ku Klux Klan, and by rioters against African Americans.

Sometimes whites were lynched; Italian immigrants are known to have been lynched in New Orleans. Research in photographic archives can help us document these horrors. In fact, more whites were lynched before the Civil War than after.

In 1876, to resolve a disputed presidential election, all federal troops were withdrawn from the South, only to return in 1957 during the Little Rock school integration crisis. "The collapse of Reconstruction," a writer has noted, was "clearly an example of the terrorists winning."[14]

Life for African Americans in the United States continued to be terrifying, not only in the Deep South but in the North. At any time, without provocation, a mob incited for no obvious reason might beat blacks, destroy their property, or worse. In the South and Southwest, nauseating photographs of lynched African Americans remain as evidence of the ugliness of American life at that time. Such photographs became a genre of photography in their own right.

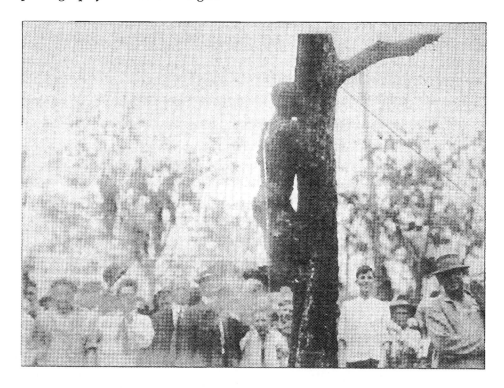

THINK ABOUT THIS

What are the implications of the fact that photographs were made into postcards that were collected and sent through the mail as curiosities about the American past?

For further research, see:
http://memory.loc.gov/ammem/vfwhtml/vfwhome.html

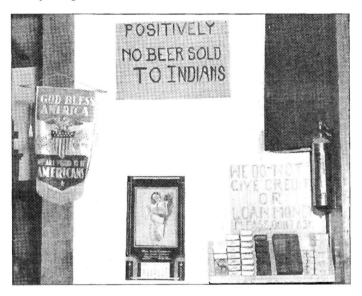

Ever since the nineteenth century, whites have treated Native Americans with disdain and prejudice. The photograph (above) of a sign from a grocery store in a western state demonstrates this prejudice. On the other hand, small town life reflected a surface placidity lacking animus against specific groups. Below is a barber shop in the Midwest during the 1910s.

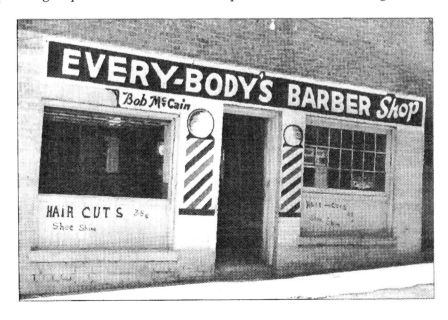

Wartime Images

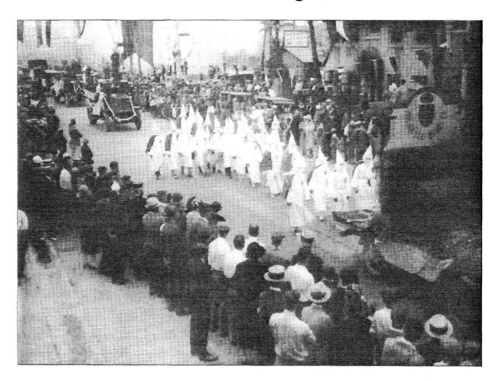

The nativist Ku Klux Klan claimed to be the defender of American values, racial and ethnic purity. Pageants such as the one in this photograph were held frequently in many eastern and midwestern cities to recruit members and to spread the Klan's ideology. Note how one of the floats in this Klan rally in Miami was sponsored by a local import-export business, thus lending it a sense of community legitimacy.

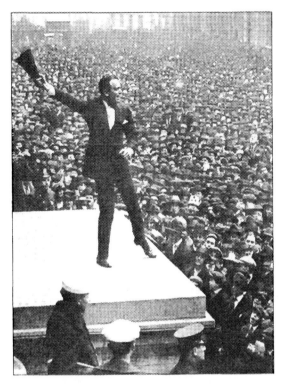

By the mid-1910s, mass culture had made strong inroads into American life. Here, silent movie actor Douglas Fairbanks, Jr. addresses a crowd, exhorting them to buy war bonds.

In reality, this (below) was what the soldiers faced at the front.

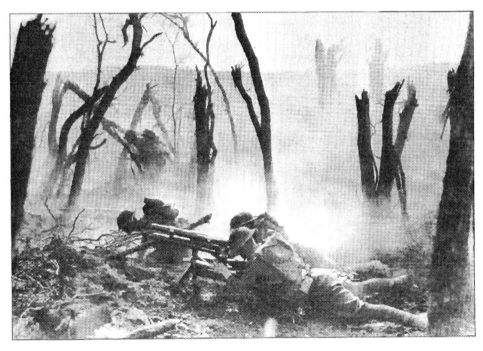

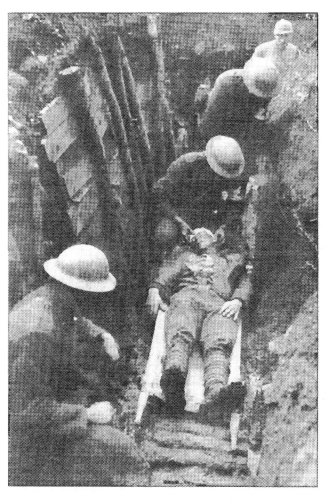

Here, a wounded Marine is being lifted gingerly on a stretcher out of a trench in the Toulon Sector, France, in March 1918, where he may have been gassed or struck by shrapnel. Was the American public prepared for such stark images of death and injury?

Another aspect of the wartime home front was xenophobia, a fear of and contempt for foreigners, especially German Americans. Many decided out of fear to anglicize their names, and some German merchants suffered attacks against their businesses. In June 1918, students from the local high school in Baraboo, Wisconsin removed all of the German-language textbooks from the bookshelves maintained by the German Department, placed them on a pile outside the school, and burned them (see photo on next page). In chalk is written "Here lies the remains of German in B.H.S." The local newspaper called it a "prank."

Activity

Using local photographic resources from repositories such as libraries, fraternal associations, newspaper archives, private collections, family albums, hospitals, and schools, seek and analyze photographs that explain pictorially how Americans of German origin were discriminated against during World War I. Try and capture the spirit in which such photographs were made. Was it mocking, intimidating, mean spirited, or something else?

YEARS OF BOOM AND BUST, 1920–1940

The decades from 1920 until 1940 experienced economic highs and lows, although the 1920s were less prosperous than many imagined, with structural flaws penetrating the American economy. Farmers did not fare well during this decade; right after the stock market crash in late 1929 things worsened precipitously. One of the reasons for the devastating impact of

the crash was that by 1930, the 200 largest U.S. corporations had owned nearly half of the nation's corporate wealth. Oligopoly had become the norm, and consumers paid the price.

The Great Depression hit working Americans hard. Efforts of union organizers to enlist members led to violent strikes and brutal repression. Mass unemployment caused widespread hardship, especially among members of minority groups and the elderly. Under President Franklin D. Roosevelt, the nation rallied behind his efforts to galvanize the federal government as a rescue agency. This resulted in the Social Security system and created jobs whenever possible, under Roosevelt's New Deal.

Social Change

By the 1920s, United States prisons held the highest percentage of inmates in relation to its population of any Western country. Some prisons, like New York State's high-security Sing Sing, were considered to be the "state of the art" in penal institutions. Men were kept in dark cells under brutal conditions with no effort spent on rehabilitation; these prisons were for punishment.

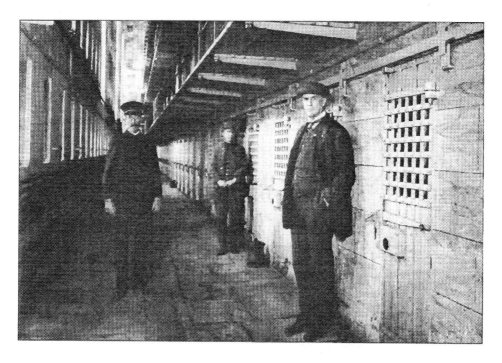

Photographs reveal evidence that racism, xenophobia, and similar hatreds rent the fabric of American society, offering evidence that the United States had far to go to claim that social justice prevailed. This photograph shows members of the racist—and occasionally violent—Ku Klux Klan marching in a street parade.

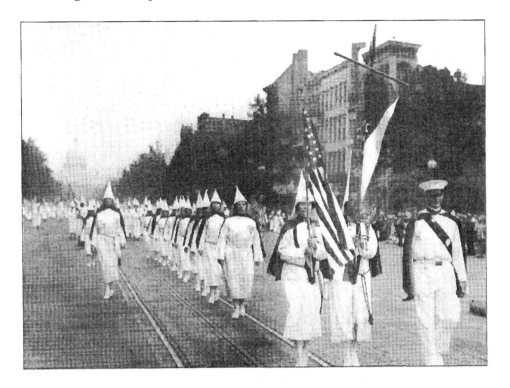

Males imposed patterns of expected behavior on women, who were threatened with social disgrace and ostracism if they did not comply. In this beach photograph, a middle aged man measures the length of a swimsuit skirt on a female, with adolescent boys watching in the background.

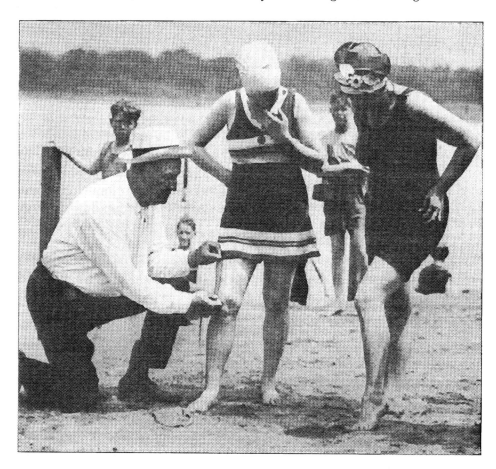

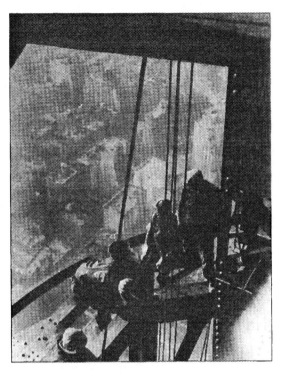

Masculine strength and bravery were also celebrated. Photographers climbed to high construction posts to capture the danger and skills of construction workers, most of them Mohawk Indians famous for their steadiness at great heights. Many drove five hours or more each weekend to return to their families on reservations in upstate New York and Quebec. These riveters on the Empire State Building were photographed by Lewis Hine, then in his early 60s, who climbed high above the city streets to document the burst of American energy he saw in skyscraper construction.

THINK ABOUT THIS

Whites expected photographs of Native Americans to show them wearing headdresses and displaying other forms of "exotic" culture. How surprised would viewers have been to learn that the men eighty stories or more above the ground were Native American ironworkers who drove many hours every weekend to be with their families on reservations on the New York State-Quebec border?

By this time, photographs regularly appeared in daily newspapers. This photograph shows alleged murderers, Sacco and Vanzetti, being led from court in Massachusetts. It is widely believed today that the two were railroaded because of anti-immigrant sentiment during the "Great Red Scare" of the early 1920s.

Progress

Technology affected Americans in many ways. Airplane mail service started soon after the turn of the century. By the mid-1920s, upper-middle-class families could aspire to own an automobile. In many communities, among the first to drive were women. This woman drove her husband to work every morning from Brooklyn, over the Brooklyn Bridge to Manhattan, and later drove him back. This convertible has a running board along each side, on which passengers stood to lift themselves into their seats.

THINK ABOUT THIS

Why in most families today does the father drive and the mother sit in the passenger's seat? What kind of change did the prosperity which permitted this family to purchase a handsome touring car for the wife to drive the husband to work suggest?

Mechanization transformed city life in every way from elevators to rapid transit, but it took much longer to spread to the countryside. This photograph by the African American photographer Frances B. Johnson depicts a school for blacks in rural Alabama. Many of the students had to walk for miles to reach the school.

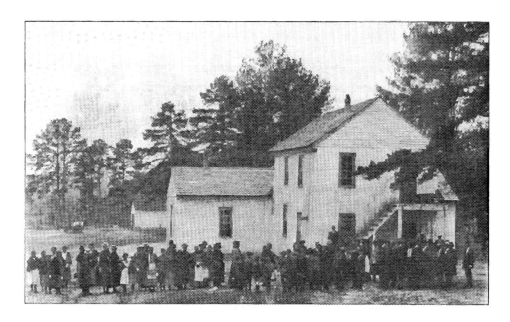

Women

Women organized in defense of their right to vote. A toddler in a baby carriage heads this suffragette parade.

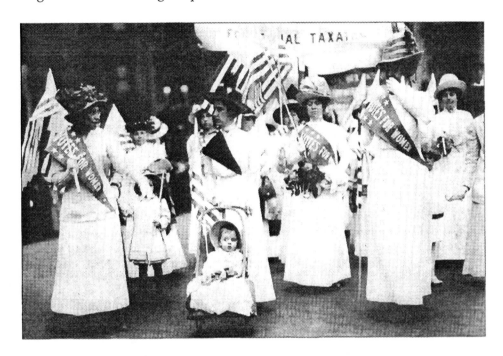

With the exception of Civil War nurse Clara Barton, the first truly American heroine was the aviatrix Amelia Earhart, who disappeared during an ill-fated attempt to fly around the world in 1937.

THINK ABOUT THIS

Would Earhart's fame have been greater or less had she completed her journey?

During the interwar years, measured by church attendance and the role of clergymen in their communities, Americans were considered to be deeply religious. This photograph seems to confirm this. Does it?

THINK ABOUT THIS

Are there men in the photograph? If not, what might this mean? What percentage of the American population attended religious services regularly at the time of this photograph?

Sports

The post-war decade ushered in the age of mass culture and heroes. Pictured batting here is Babe Ruth, traded from the Boston Red Sox by the owner of that club to the opportunistic New York Yankees. Ruth, who broke all home run records during the 1920s, is playing in the stadium that served the team before the opening of Yankee Stadium in April 1923—built with private monies.

Parallel to the rise in iconic popularity of major league baseball, accompanied by coverage in tabloid newspapers of mass circulation, were the so-called Negro Leagues. The players, African Americans and sometimes Cubans or Dominicans of dark complexion, played before enormous crowds in the same ballparks as the major league teams. They earned practically nothing, were barred from most hotels and restaurants when they traveled from city to city, but they contributed pride to their fans. Facing his teammates is Josh Gibson, decades later admitted to the National Baseball Hall of Fame.

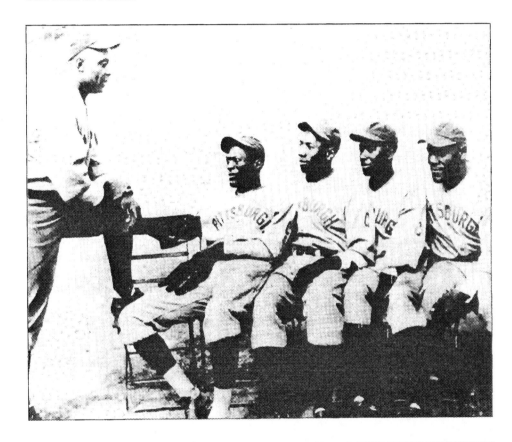

THINK ABOUT THIS

Why did whites in the South regularly attend Negro League games, even though they considered the players inferior and would have violently resisted any suggestion that racial segregation be abolished?

Activity

Identify aspects of American life that would not have been "seen" by members of the affluent middle classes during the 1920s. Look at newspapers and magazines from the period as well as other sources for photographs of such subjects as Negro League teams playing at major league baseball stadiums, and "barnstorming teams" pitting white stars against African Americans. Look for photographs of spectators to see how they were seated, by race.

Economic Changes

The later 1920s, before the stock market crash of 1929, saw millions of Americans hoping to improve their economic status and even to become rich. Many bought stocks on margin; others purchased land. Here is a snapshot from a photograph album on which someone has written "Our Land in Florida." In all likelihood, the land was repossessed by the bank for lack of payments.

Rural Life

In rural America, life went on as usual, although many farmers and ranchers lost their land as wholesale prices for food dropped. Here a man in the Dust Bowl drinks water, the most precious commodity in the region.

Agricultural laborers, many of them Mexican and or African American, suffered terribly during the Great Depression. Most residents of the United States had no awareness of the hardships under which people lived in order to make a living. Consider this photograph taken by an employee of the federal Farm Security Administration (FSA), an agency that employed photographers to document how Americans were coping with the hardships of the Depression.

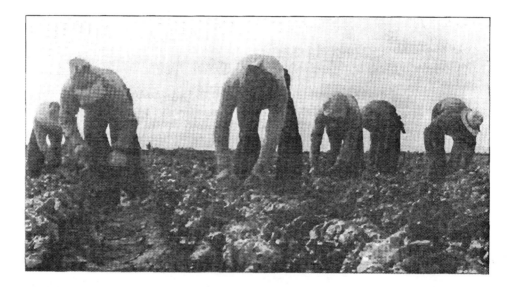

THINK ABOUT THIS

Some analysts have labeled the work done by FSA photographers as "political" or "reformist" photography. Was this consistent with the national mood during the Depression?

This famous 1936 Farm Security Administration photograph, taken in a small rural Mississippi town, depicts the powerful influence of the white "boss," stuffed into his clothing, leaning against his automobile and dominating the scene. He dwarfs the men sitting behind him. The photograph seems to mirror the social environment in the Deep South, which many African Americans fled after 1940 seeking industrial jobs in northern factories.

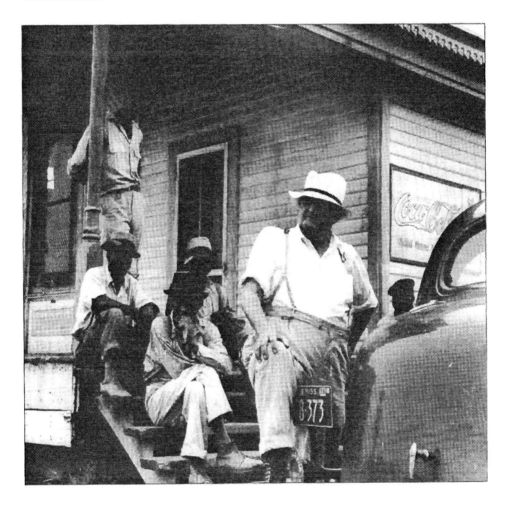

Families from the plains states were often dubbed "Okies" because so many came from Oklahoma, where droughts had been unusually severe. They relied on their automobiles for seeking work, until the cars gave out.

Images of the Depression

The Great Depression had a profound effect on many aspects of American life, and photographs captured the mood and social values of that difficult era.

Even though American families had little disposable income during the 1930s, they faithfully attended Hollywood films, especially on Saturday nights, or they sat at home listening to their radios. The habit of listening to the radio continued well into and beyond World War II, as Americans sought news about the war and the aspects of postwar recovery.

In cities, municipal officials as well as private charities ran soup kitchens, where the unemployed could receive a meal of soup and bread.

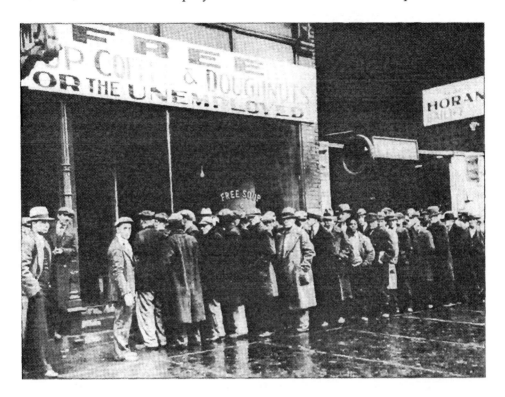

THINK ABOUT THIS

Why might there have been no women in line? Why only one African American? Why does the large sign above the entrance read "Free coffee & doughnuts for the unemployed," whereas there are the words "Free Soup" on the glass window?

The elderly were hit hard by the Depression. Few, if any, state or federal agencies ministered to their needs. In cities private institutions such as churches provided soup kitchens, but in rural America older men and women, often physically distant from family members, faced starvation.

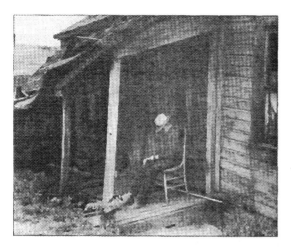

Many farmers lost their land when banks foreclosed on their mortgages. The photograph below from the Farm Security Administration is often mistitled "men standing on bread line." Close examination reveals that the white-shirted clerk holding the pencil is handing a check or other document to the farmer, standing with hat in hand; on the check is printed "Treasury of the United States." The other men on line await their turn, but the man facing front, scrutinizing his check, seems very unhappy. In contrast to the period since the 1950s, when farmers began to receive subsidies from the federal government when prices fell, assistance from state and federal government for farmers during the 1930s was minimal.

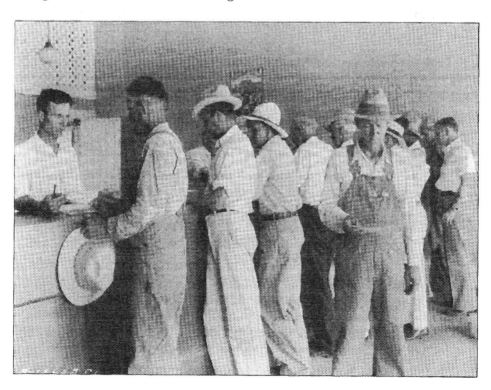

Some of the most insightful photographers of the 1930s captured the class ironies that underscored American life. Pay attention to this billboard, which could well have been seen by indigent migrants traveling to the picking fields in California.

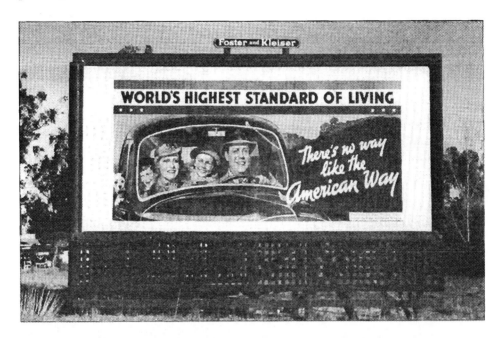

THINK ABOUT THIS

Thousands of familiar images about the Great Depression emphasize the arduous conditions under which millions of Americans lived. They are "political photographs," and they leave us with such questions as: "Why did this happen?" "What is wrong here?" On the other hand, try to find examples of photographs showing the other side: Upper middle class life was not visibly affected by the Depression, nor were the lives of the wealthy elite and the lives of persons whose skills or business activities left them in good stead economically. Can this be documented photographically?

CONFLICT AND RECOVERY, 1940–1970

Even more hurtful was racial segregation in the American South. This business has posted a sign that clearly reads "We Cater to White Trade Only." This means that other businesses and stores in this community only served blacks, who were also limited to segregated drinking fountains, bus stations, lunch counters, and were not accepted in most hotels or restaurants. Racial segregation remained the law in force in most southern states through the late 1950s, and in terms of housing and schools often remains in place even today.

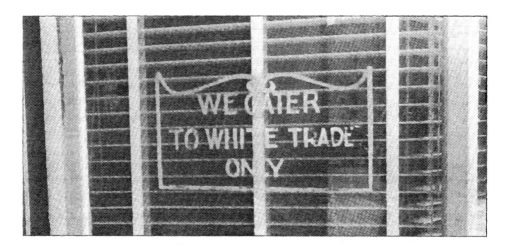

The Home Front during World War II

Immediately after Pearl Harbor, rumors spread wildly among Japanese Americans that the United States Army or the FBI would ransack their houses. A college sophomore recalled the period before internment:

"I think every family must have gone through their houses in search of incriminating articles. Of course most of the items were harmless, yet the FBI agents had a funny way of interpreting innocent articles. We must have burned 50 or 75 books, merely because they were written in Japanese. I spied my mother with tears burning pictures of her relatives back in Japan, looking at them one by one for the last time and burning them."[15]

Japanese Americans, then, burned their kimonos, diaries, Japanese language books, letters, and photographs. Their cameras and radios were confiscated. Yoshiko Uchida remembers that his family's Brownie cameras had to be brought to the Berkeley, California, police station, where the cameras remained throughout the war.[16] *Issei* (first generation Japanese Americans) took many formal photographs of family milestones—birthdays, weddings, reunions, even funerals. Many families photographed every visitor to their homes. One reason was to share the events with their relatives in Japan.

German Americans in New York's Yorktown owned binoculars, short wave radios, and Leica cameras, all of which were taken by authorities and locked in vaults for the course of the war.

Here, Clem Albers captured a poignant scene of the Yamagata family relocated to an interment camp in Arcadia, California in, 1942.

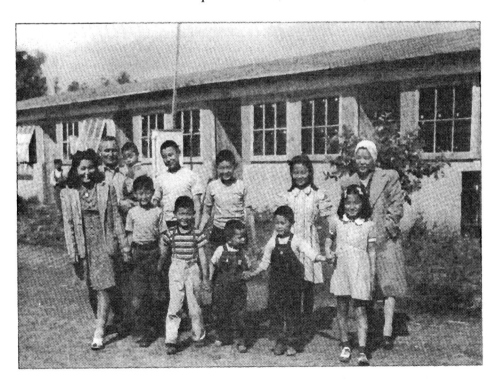

THINK ABOUT THIS

Consider this early 1940s photograph of a Mexican American youth. He is wearing what was called a zoot suit. His baggy pegged pants are too long, as is his tailored striped jacket, which has padded shoulders, and exaggerated lapels. He wears a floppy felt hat with a feather. His pose is jaunty, and he clasps his hands behind his back. On June 4, 1943, sailors, many of them drunk, rode in as many as 200 taxis and cars through the streets of Los Angeles to find and assault Mexicans dressed in zoot suits. The unprovoked beatings and attacks provoked riots throughout the city that lasted for five days. The clash represented a conflict of cultures: The sailors had been uprooted from their home towns across the country and stationed in boot camps. The Mexican Americans, many of whom were working in war industries, were faring relatively well economically. The popularity of zoot suits among *chicano* teens contrasted with the uniforms of the sailors and offered an outlet for pent-up racial and anti-immigrant prejudice among whites.

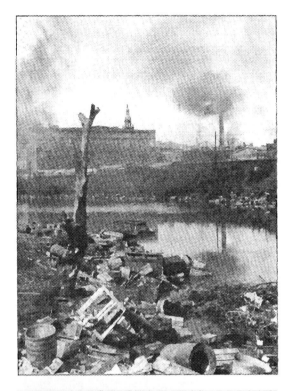

When we think of America's farmlands, industrial pollution usually does not come to mind. In this photograph, taken outside Dubuque, Iowa in the early 1940s, a smokestack belches dirty smoke. It paled in comparison to the filth covering such gritty factory cities as Pittsburgh, but it surprises us because we do not associate industrial pollution with the farm belt.

Although industrial preparation for the possibility of war had created millions of new jobs and improved economic conditions for many Americans, the poverty of the Great Depression had lingered across the nation, especially among marginalized minority groups. Wartime not only brought jobs for women and members of minority groups, mostly African Americans who left the cotton fields of the South in search of factory work in northern cities, it also generated a surge of patriotic support for the Allied effort.

President Franklin D. Roosevelt, elected to four terms, led the nation until his death in 1945. One of the things hidden from public view was that Roosevelt, a paraplegic since contracting polio in his late 30s, was always photographed in ways that did not show his disability, which in those years was considered something to be hidden. Metal braces propped him up while he was not sitting. Had the American public known that he was what was then called a "cripple," his vote-getting ability might have suffered.

THINK ABOUT THIS

Is there any visual evidence in the photograph on the previous page that Roosevelt's pose was staged in order to give the impression that he had full command of his body?

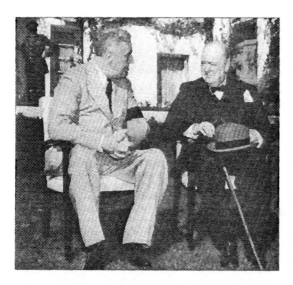

Here, Roosevelt sits talking with Winston Churchill, the British Prime Minister.

In addition, United States military regulations limited publication of photographs or filmed images showing American casualties. For this reason, the thousands of photographs taken by combat photographers during the war, although quite graphic, never revealed to the public the graphic horrors of such fictionalized films as *Saving Private Ryan* or *Pearl Harbor*.

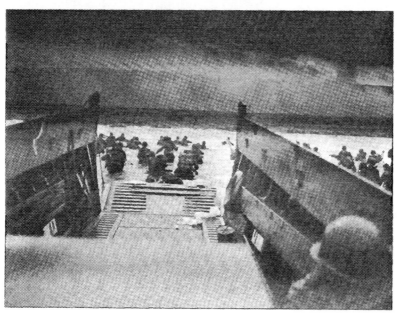

The enormous need for manufactured products during wartime enticed hundreds of thousands of African Americans to leave the rural South in search of employment, even though once in the North they faced housing shortages and racial discrimination. This photograph shows an African American woman performing industrial work as a riveter. When the war ended, most lost their jobs.

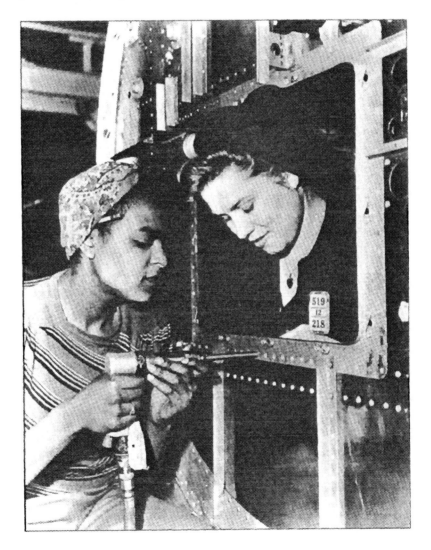

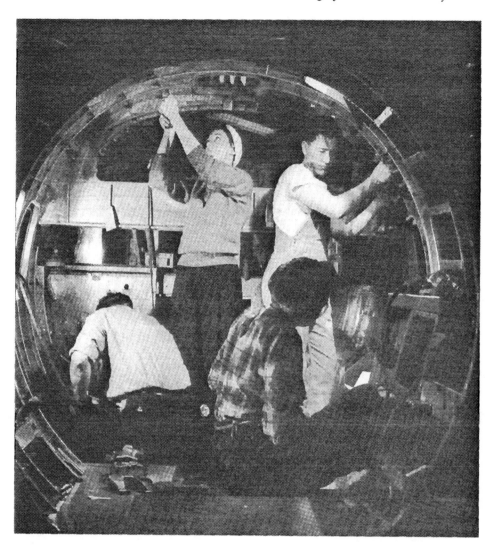

Here, men and women work together at an airplane assembly plant in Seattle, Washington.

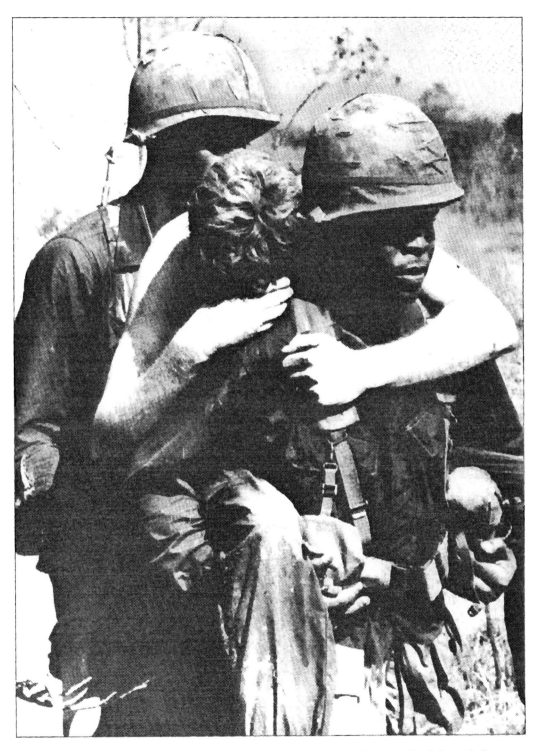

An American infantryman carries a wounded comrade on his back after a fire fight with the Viet Cong in Vietnam in 1968.

III

Recent America, 1945–Present

The return of millions of American servicemen and women underscored the great need for housing and jump-started industrial prosperity. Millions of people purchased cars and trucks; millions more attained the economic security that permitted them to buy homes, take vacations, and fulfill the American dream.

The post–World War II years also saw the emergence of a patriotic hysteria, symbolized by the anticommunist crusade of the rabble-rousing Senator Joseph McCarthy of Wisconsin, and by a "Red Scare" in the American entertainment industry that rivaled the Red Scare that followed World War I. The decades of the 1950s and 1960s were marked by the heroic beginnings of the civil rights movement, and, after the assassination of President John F. Kennedy, by the Vietnam War and by the anti-war movement at home. This seemingly endless conflict ended in the 1970s with Watergate and the humiliating resignation of President Richard M. Nixon.

The 1980s brought demographic changes as Americans of Hispanic and Asian origin grew proportionately in the population and made their marks culturally, as other immigrant groups had done in earlier decades. Yet looking introspectively at the culture of the 1950s and beyond, we can see that the period was self-critical and alive with change. Mass culture came under criticism, and the advent of the computer revolutionized communications in ways never anticipated a generation before.

Postwar American life took on a laid-back, happy-go-lucky sense, as depicted by this odd-shaped coffee shop and liquor store.

For further study, see: http://www.ipass.net/~whitetho/, on the history of the radio industry in the United States.

Three young boys avidly watch an early black-and-white television set in the 1950s. Note that the television is in a wooden console cabinet, and appears to be an important piece of furniture in the room. A special vase sits on top of the console.

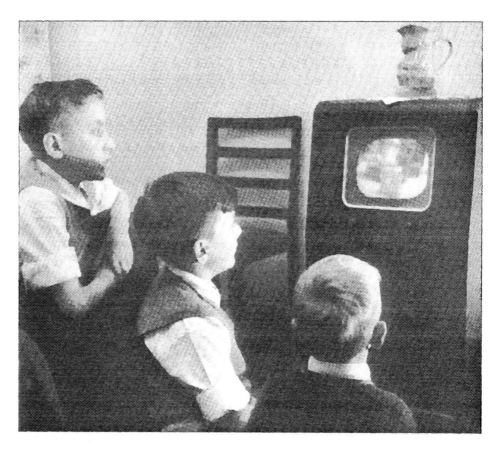

THINK ABOUT THIS

What changes in American life likely occurred as a byproduct of the fact that by 1958, 83 percent of American families owned a television set, and that by the same year, the number of two-car families had doubled since 1951?

Suburbia

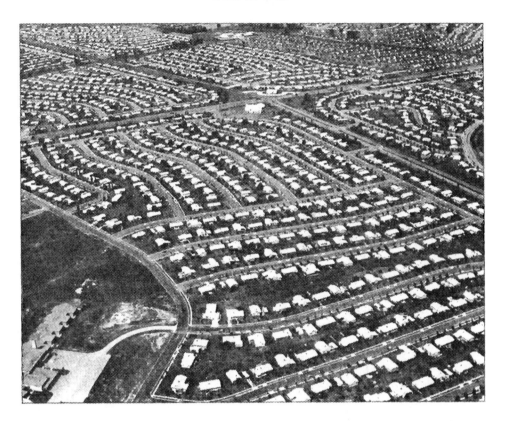

Veterans returning from military service found that veteran's aid programs, as well as creative lending practices by developers such as William Levitt (the builder of small homes on large tracts of land near Philadelphia and in former potato fields on Long Island), gave middle class families opportunities to buy homes with long mortgage periods, leading to the growth of what became known as suburbia.

THINK ABOUT THIS

How did the uniformity of subdivisions and the cookie-cutter design of houses in suburban planning likely affect the quality of life for those who lived there?

For further study see:
http://tigger.uic.edu/~pbhales/Levittown.html

After World War II, federal government aid to banks permitted long-term mortgages—often 20 years or more—as did loans to veterans, which spawned the rise of housing developments. These were typically constructed on former farm land at the periphery of urban areas. This photograph from Nassau County, New York, shows a subdivision home about five years after the development's construction. The trees planted at the time of construction have grown modestly, and the lawns—a hallmark of suburbia—are established. The house seems identical to its neighbor.

In the scene, a small child boards a day-camp van in front of her house. Unlike small towns and rural areas, life for children in suburbia was often filled with programmed activities: dance classes, Little League baseball, youth groups, and so on.

THINK ABOUT THIS

Did suburban life differ for children in other ways (see pages 114 and 115)? What might have been the impact of growing up in neighborhoods with "cookie-cutter" homes? How did suburban developments change over time?

As American society recovered from the strain of World War II, full employment in industrial jobs, which saw workers manufacturing tool parts, furniture, automobiles, steel ingots, and a myriad of other consumer products, definitively ended the Great Depression and ushered in an age of unprecedented prosperity. In this photograph, a DuPont Corporation cameraman laid out the food to be consumed yearly by the average family of four, using DuPont worker Steve Czekalinski, his wife, and two boys, as models. The American dream seemed to have suddenly and systematically come true.

THINK ABOUT THIS

How might viewers from countries in the developing world and poor Americans have reacted when shown the photograph on page 116? From the Soviet Bloc? From the inner cities of the United States or from Appalachia? Is there a reason for the fact that the family in the photo, the Czekalinskis, of Polish immigrant background, was selected to display American material success?

Suburban lifestyles did not always reflect the majority culture. Cubans who came to Miami during the years Batista was in power in the 1950s and (later those who fled Fidel Castro in the early 1960s) transplanted their family customs. Here a young family prepares a pig for roasting in the backyard of their suburban Miami home.

Civil Discord

At the height of the Civil Rights movement, federal marshals escort young African American students to Central High School in Little Rock, Arkansas in an armored vehicle, in 1957. Armed soldiers stand guard nearby. Notice the impeccable manner in which the teenagers are dressed, although they would later be spat upon by whites.

Organized labor waged battles against employers throughout the postwar period. The public faced work stoppages from mail delivery to automobile manufacturing and steel production, to transportation and farm production. Some strikes turned violent, as they had done during the 1930s. The UAW (United Auto Workers) Local 833 strike of the Kolher Manufacturing Company of Sheboygan, Wisconsin, lasted from 1954 through 1965, a total of eleven years.

In this photograph, farm workers demonstrate on a picket line during the King Farm strike near Morrisville, Pennsylvania.

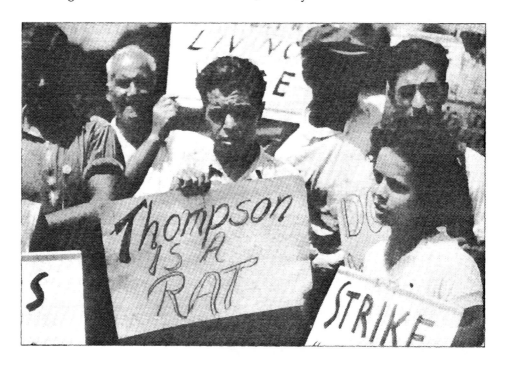

THINK ABOUT THIS

Note the presence of women in this photograph. Would you have expected the same in the 1920s or 1930s? Why?

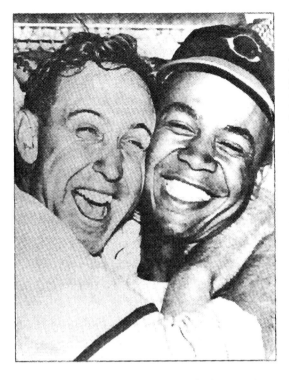

Changing Attitudes

Photographs in the mass media recorded subtle changes in American life. In 1948, the Cleveland Indians won the World Series, led by Larry Doby, the first black ballplayer permitted to play in the American League. On the day following the victory, the *Cleveland Plain Dealer* published this photograph of Doby being hugged by Cleveland pitcher Steve Gromek, who was white. Before World War II this photograph would have been considered by many to be "unnatural" and harmful. But in Gromek's *New York Times* obituary on March 23, 2002, the caption read: "Steve Gromek, 82, a Pitcher Who Is Best Known for a Picture." "A Larry Doby hug," the caption continued, "became a statement about integration."

This photograph (on the left) illustrates the comprehensive changes in attitudes in American society. Two women and two men stand, holding drinks, in a "liberated" atmosphere.

> ### THINK ABOUT THIS
>
> What social attitudes do their clothing and poses convey?

Popular Culture

The decade from 1960–1970 was known not only for its youth culture and passionate debate over the Vietnam War, but also because many Americans gravitated toward activities providing solace and community. Here, we see members of a Pentecostal sect whose worship featured "speaking in tongues" and the use of live snakes. Although not a mainstream form of worship, their beliefs provided the congregation with a sense of community.

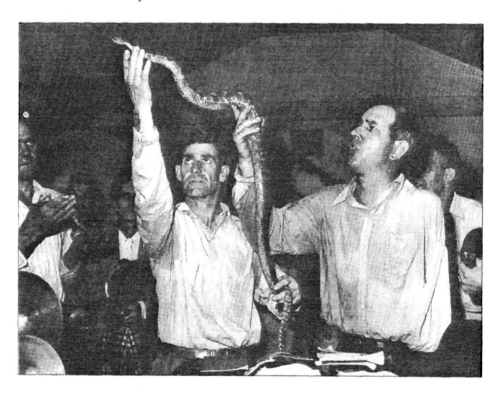

This photograph of a Hialeah, Florida, flea market in 1974 evokes the flavor of a characteristic American institution.

THINK ABOUT THIS

What information can we gather from the way the woman is dressed, and how she poses in front of her wares? What about her body language?

Ideological Divisions

Here, student protestors sit in support of fellow anti-Vietnam War activists who are occupying Van Hise Hall, the administration building of the University of Wisconsin.

THINK ABOUT THIS

How did the photographer's choice of a wide angle lens, used to emphasize the seated students at the bottom of the photograph, add tension to the composition?

Although the choice of lens and other technical data affect the way viewers consider a depicted subject, most important is the context in which the subject is understood. This photograph of Chicago's Mayor James Daley was taken in 1968, around the time of the ugly riots between protesters and police during the Democratic National Convention, when the blood of protesters ran in the streets. Those who liked and admired Mayor Daley probably considered this photograph a handsome likeness. Others, opposed to his practices as mayor, probably recoiled from it, seeing in it hateful reflections of repressiveness.

Over time, the way photographs were composed (and the reasons behind editors' decisions to use one photo or another of the same subject) influenced the way prominent people have been seen by the public. Richard M. Nixon, as vice-president and especially as president, accused press photographers and news editors of selecting the most unflattering shots of him because they opposed him politically. Not only did photographers come under attack from Nixon but also political cartoonists, especially Herb Block (HERBLOCK), who depicted Nixon with sagging jowls and a permanent "five-o'clock shadow." To the extent that photojournalists take hundreds of shots for every one published, and that editors are free to choose images that are flattering or unflattering as they wish, Nixon had a point.

This caricature of Nixon is the artist's interpretation of his subject.

THINK ABOUT THIS

How far does the cartoon diverge from Nixon's actual features as seen in the photograph of him speaking seriously? To what extent does one's self-image color how one reacts to one's photo?

Patriotic Pride

Iconic images helped fix the worldwide image of the United States as a scientific and military superpower. President John F. Kennedy pledged during his first term to send Americans to the moon by the end of the decade. The promise came to fruition in 1969, with the Apollo 11 mission. In this world-famous photograph, Eugene A. Cernan, commander of Apollo 17, is seen saluting the flag on the lunar surface during NASA's final lunar landing in December 1972. Astronaut Harrison Schmitt, also on the moon's surface, took the photograph of his fellow crew member.

THINK ABOUT THIS

What might there have been about the photograph on the previous page that led some to claim that the NASA missions to the moon were hoaxes? What led some in developing countries to view the achievement of the Apollo missions of the United States as symbolic of American arrogance? What did Astronaut Cernan's saluting the flag mean to viewers of this image in 1972?

Social Change

More than 700,000 refugees from Castro's Cuba settled in Miami, Florida, from the early 1960s through the 1980 Mariel boatlift and the arrival of thousands of refugees by raft during the 1990s. Some were smuggled in via the Bahamas, and others risked their lives on makeshift vessels made of inner tubes or logs lashed together. This young couple stands in the lobby of a fleabag Miami Beach hotel, where the posted signs make it clear that guests are not to be trusted (see page 128).

THINK ABOUT THIS

What does the body language of the young couple in the hotel lobby suggest? Does the young man's face show determination or frustration? What is the impact of the photographer's placement of the man's face in what appears to be a spotlight of light?

This 1987 photograph taken in downtown Miami depicts bystanders running toward a small group standing in front of a stand of trees. A man stands with fists raised in the air, egging on the group running forward. The open plaza is fenced off, and behind it stands a large crowd, some holding placards. A pro-Sandinista group opposed to United States aid being sent to the Nicaraguan *contras* (counterrevolutionaries) had held the initial protest.

Speakers representing the Cuban exiles' position of support for the *contras* had stirred up the pro-*contra* crowd against the anti-*contra* group, which had to be evacuated in school buses by police, for their protection. Bottles, eggs, and rocks had been thrown at the anti-*contra* group. The angry counter-protesters in the photograph were surging forward to the spot where the pro-Sandinista rally had been held. Photographer Juan Carlos Espinosa remembers that he had to dodge flying eggs as he made his way between the two groups.

The photograph captures the volatile atmosphere that has characterized life in Miami during the forty-plus years of Cuban exile life, just ninety miles from Havana.

Several years later, in 1994, a standoff between the governments of the United States and Cuba led to thousands of rafters attempting to gain entry to the mainland, only to be turned back and interned for more than a year at the United States naval base at Guantánamo Bay.

THINK ABOUT THIS

How does the way the men are posing make us feel about them? Do they seem menacing? Passive? Cheerful?

For further study, see: http://www.uflib.ufl.edu/flnews/cuban.html

Another changing social value was that of showing more respect for the independence of elders. Here, photographer David Sweet captured a couple at a dance party in a facility for retirees. This photograph would not likely have been taken a generation earlier. There was growing acceptance of the right among the elderly to individuality and sexual privacy. The couple, José Hanano and Iriade Habibe, both widowed, had

met at the facility, and discovered that as children they had known one another. They subsequently married.

For further study, see: http://www.ourseniorvears.com/isolation.html

Social Anxiety

Photos reveal underlying tensions and animosities beneath the surface. Below is a 2001 photograph of Ku Klux Klan members in Defiance, Ohio. The man in the dark hood, Mr. Berry, is now serving a seven-year prison sentence for Klan-related activities. He was being interviewed by reporters from a television station in Kentucky. When the interview turned sour, Mr. Berry demanded the tape. When the journalists refused, one of Berry's accomplices pulled a gun and refused to let the reporters leave. Berry did not get the tape and received a prison sentence for other Klan-related activities. Berry's lawyer raised the concern that his client was fearful of his safety in prison.

Pictorial elements worth analyzing include the vertical metal mesh fence separating bystanders from the Klan members, who hold Confederate flags as if to display their contempt for those whom their ideology attacks. The bystanders appear to be watching passively. No one—as often occurs at public appearances by hooded Klan members—seems to be protesting or waving anti-Klan posters or signs. The banner identifies the Klan group as the American Knights of the Ku Klux Klan, an irony given the Ohio Klan's choice of the Confederate banners under which to stand.

Photographs can reveal the devastation of the inner city environment when buildings are abandoned, gutted, and boarded up.

THINK ABOUT THIS

What visual similarities are present between this photograph and the images earlier in this book of the destruction of Richmond and Charleston at the conclusion of the Civil War?

Everyday Life

Urban spaces filled with graffiti sometimes serve as territorial markers for gangs; at other times, they are anonymous (or not anonymous) messages left for all to see. Here is one painted on the sidewalk on Boston's waterfront in 2002.

Twentieth-century America has seen the emergence of cults of celebrity worship, none deeper and longer lasting than the Elvis Presley phenomenon. Even though his final years were plagued with personal dissoluteness and he eventually died from drug and prescription medication overdoses, Elvis remained an iconic figure in popular culture. This photograph from 1997 shows a pair of Elvis impersonators in Memphis.

THINK ABOUT THIS

Is it meaningful that one of the boys is African American, given the fact that Presley came from Tupelo, Mississippi, in the heart of the Deep South, and, although not personally racist in his behavior, the Elvis cult has not always been embraced by Americans of color?

For further study, see: http://www.elvis.com

During the 1990s, as in other decades, photographs taken reveal visual clues about American society. Here, for example, a group of cheerleaders at Washington University in St. Louis perform. Colleges became more diverse in the '90s. One of the young women in this photograph is Asian, while the others are white.

THINK ABOUT THIS

At many large universities, cheerleading squads during the 1990s often fell into segregated patterns, with dancers being predominately African American, and cheerleaders mostly white. Why would this have been the case?

This photograph, taken in the early 1990s, would not have caused the same shock then that it does for us now. These visitors to New York City were taking the Circle Line cruise around New York harbor, with the Statue of Liberty and twin World Trade Center towers forming a natural part of the background. What thoughts go through our minds today?

Since the late 1980s, cartoonist Ben Katchor has been publishing one-page strips in black-and-white and in color, following the adventures of a fictional character, Julius Knipl, Real Estate Photographer. Knipl, a middle-aged photographer, works in the city, in the drab ocean of decaying buildings, warehouses, and discount stores. He works out of a fly-infested office and spends hours waiting for the light to fall just right on a run-down building, so that gullible clients looking for apartments to rent will be fooled into thinking it is attractive.

The photograph on the next page from West Philadelphia demonstrates the comic strip's premise. The four-story mural, painted on the wall that separated the existing row house from a demolished adjacent building, presents a fantasy-based rendering of urban renewal. The mural depicts a gentrified home, a house of worship, shops, and a soaring office building.

THINK ABOUT THIS

What visual message is conveyed by the parked cars? What would be the difference, if any, if photographed murals of actual modernized buildings were substituted for photographic murals of projected modernized buildings?

Sometimes a coat of fresh paint gives the appearance of renewal. This photograph taken from the top of an open-decked bus in New York's Harlem reveals some improvements in the individual apartments. Some of the windows have air-conditioning units, and some of the window frames appear to be new. (See page 138)

September 11, 2001

The horrendous images broadcast over television and reproduced in newspapers and magazines across the world generated a host of photographic images considered to be in bad taste. Some tabloid newspapers showed the horrifying images of employees jumping to their deaths from the World Trade Center towers. Other photographers, using digital devices, invented fraudulent scenes showing people standing on the observation deck with one or both of the hijacked airplanes approaching. These images spread throughout the world via the Internet, but were soon revealed to be counterfeit.

The visual images of the devastation caused by the destruction of the towers traumatized those who saw the photographs, in a more powerful manner than any similar photographs of the twentieth century. The photograph on the next page shows the reality of the burning towers after the hijacked planes struck the World Trade Center towers the morning of September 11, 2001.

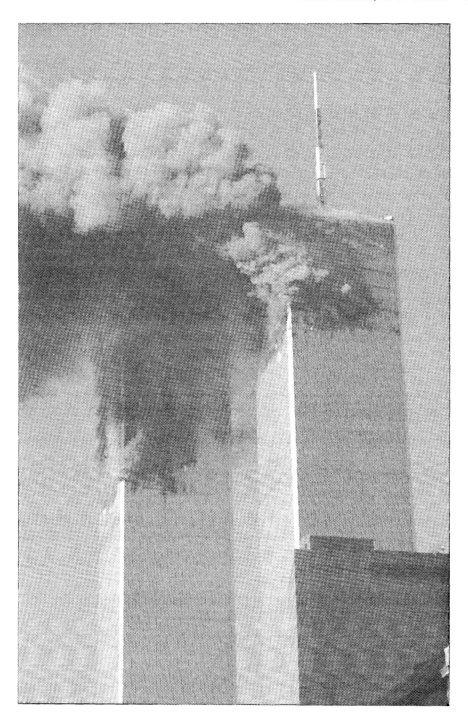

Here firefighters are working at the site where the World Trade Center towers collapsed (also called "Ground Zero"). The fires are still burning and the emergency workers are looking through the rubble for survivors.

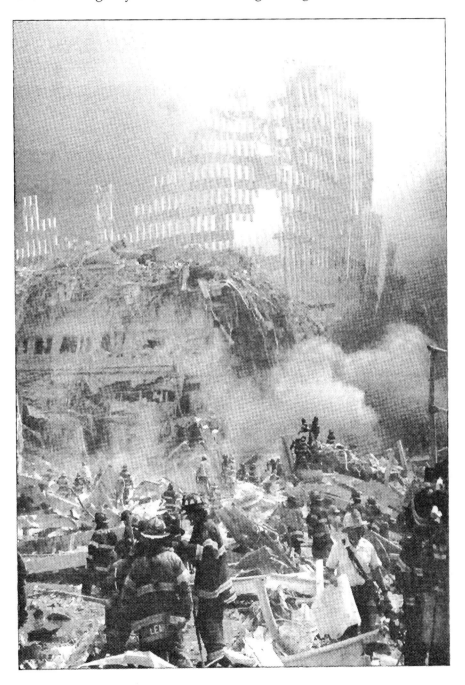

Within weeks of September 11, 2001, Ground Zero in downtown New York had become transformed into a shrine where thousands of visitors came every day to stand on line to watch the first stages of the excavation process, and to pay homage to the firefighters, policemen, and rescue workers who had sacrificed so much in saving the lives of so many. Here, a policeman guards one of the thousands of makeshift shrines erected out of banners constructed by schoolchildren and placed by fraternal and other community groups that traveled to New York City from all parts of the country to pay their respects.

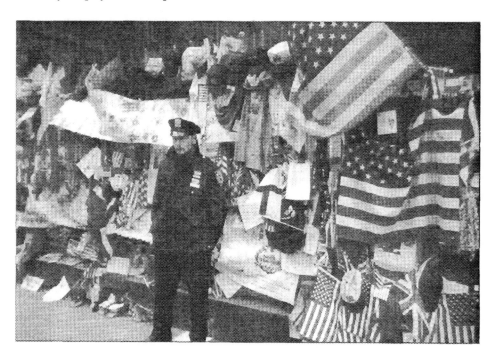

Activity

Consider the following set of hypotheses about photography and American society. Using the Internet and published news magazines or other sources, find photographs that meet the following criteria, then discuss your findings.

If we examine photographs in the last few decades of *People* magazine or other photojournalism sources, we might come away with the following conclusions about American society in the middle-twentieth century:[17]

1. The automobile dominates American life; Americans love their cars and trucks and practically live in them;
2. They also revere the flag, but sometimes display it to intimidate;
3. Religious symbolism is also universal but only among African Americans does religion seem to be a vital, living force;
4. Males are valued for their physique, women for their sexuality;
5. Women lack power and are valued mostly as adornments to men. They are principally concerned with their appearance and flaunt their bodies;
6. People over the age of forty are devalued and ignored, as are people who are overweight, poor, or not photogenic.

THINK ABOUT THIS

What are some other themes or ways of depicting people in today's visual imagery that might be added to this list?

Activity

Explore photographs in an archive for information about changing social norms.

1. Find examples of 1920s and 1930s jazz bands and evidence of racial integration.
2. Look at audiences at popular music concerts during the late 1940s and early 1950s, when for the first time audiences were permitted to integrate.
3. Find photographs taken during athletic events, theatrical performances, or graduation ceremonies at integrated public schools. To what extent were audiences segregated (or self-segregated)?
4. Examine "official" photographs (for example, those used in advertising or to promote government programs). In what years did the first disabled person appear? The first person of Native American origin? The first interracial couple or family? What does this tell us about changing social perceptions?
5. Look at photographs of crowds during the period between 1900 and 1930. What kind of rules governed the way men and women dressed in public? Based on your photo research, when did these rules start to change?

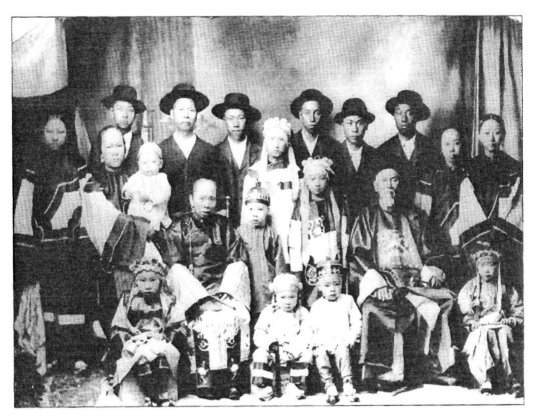

A Chinese wedding party that took place in Idaho in the early twentieth century.

IV

"Say Cheese": Family Photographs

Family albums demonstrate that ordinary family members are part of history. They reveal much about relationships within families, changing roles of children and the elderly, and about economic change.

Activity

Using family albums documenting least three generations (they may be found not only in private homes but also in archives and historical society holdings), analyze the changes that the photographs reveal. These may or not be limited to implied relationships of power within the family structure, evidence of upward or downward socioeconomic mobility, and examples of discord or harmony.

The introduction in 1888 of the Kodak camera by George Eastman—a portable box camera that permitted amateurs to shoot their own pictures outdoors—changed the impact of photography on family life. The camera contained film for one hundred exposures and sold for twenty-five dollars. In time, the cost of Kodak cameras came down to the point where they became affordable for the rising middle class.

Studio photographers, however, continued to play a major role in portraying families. By the early 1920s, some customers sat for formal portraits to demonstrate their affluence. By now, many families could afford to take their children to photographic studios for formal portraits. Sitting fees included clothing wearers could borrow to suggest prosperity, even wedding dresses for women and three-piece suits for men. Studios provided the props. In the photo on the next page, the youngest child sits on an ornate hassock, the young boy on a simulated wall. This 1923 photograph suggests that the subjects live in a mansion, although the scene behind them is a hand painted backdrop. The well-dressed children do not smile exaggeratedly, but seem to show contentment.

Images by Tourists

As soon as a passenger ship sailing to Hawaii entered the harbor, Hawaiian natives, working for local officials, placed floral leis around the neck of each passenger. Ship photographers also snapped pictures of each new arrival and sold them to the passengers when they came back aboard ship at the end of their land tour. This gave ample time to develop and print the images.

Photograph albums recorded the lives of families in a carefully staged manner. Consider the 1914 snapshot (on the top of the next page) from the album of a well-traveled Ohio family, taken on vacation in the Bahamas. "Prof. Shaw" poses in a full white suit with his hands resting on the shoulders of two small black boys, standing apart from two black men wearing working clothes. "Dr. D's" family members stand lined up to his left as he waves cheerfully.

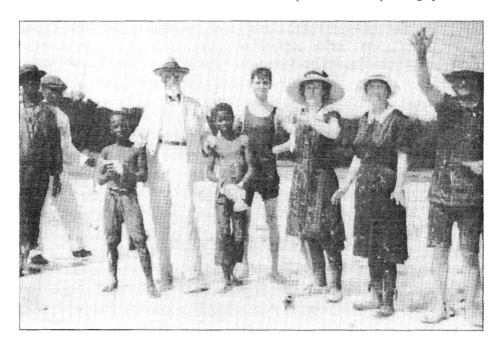

THINK ABOUT THIS

Does the relationship between the whites and blacks in the photograph offer a commentary on the racial attitudes held by many Americans in the early years of the twentieth century? What commentary?

American society in the early twentieth century demanded that women display what was considered to be proper decorum while in public. Here, members of a family enjoy themselves while swimming. Although the bathers, all women, keep their bodies well under water, we can be sure their "bathing costumes" covered their arms and legs once they climbed out of the lake.

Americans stationed abroad, or traveling as part of their jobs, often took the same kinds of snapshots of locals that they would if nearer home. This photograph taken by an oil company engineering team in Mexico during the early 1920s ended up in a photograph album with the demeaning caption, "They enjoy having their photo taken."

They enjoy having their photo taken.

THINK ABOUT THIS

What feelings do we experience viewing huts made of tree branches, lacking windows? Why are the men smiling at the camera? What else is in the picture? What does the caption tell us about the person who added the photograph to the album?

Mom - way out West. 6-24-49

Reno + slot machines, here we come!

Just past Wenderer, Utah

This Brownie snapshot, captioned in the margins, "Just past Wenderer, Utah," "Mom—way out West," and "Reno & slot machines, here we come!" was taken during a family car trip west from the state of Wisconsin, in June 1949. Three generations rode in the family sedan—two children, their parents, and a grandmother, the "Mom" in the caption.

The Nevada State Line sign lists the state's self-proclaimed attributes: No Income Tax, No Sales Tax, No Inheritance Tax, No Corporation Tax, No Gift Tax, and, in large letters, "A Debt Free State Welcomes You." The woman stands stiffly, holding her handbag tightly to her coat, as if protecting it from the lure of the casinos, or perhaps from robbers. As the ranking member of the family, she probably was holding the family's vacation money. A majority of Americans of her generation stood rigidly when being photographed. "Say cheese" came later; the camera intimidated, and even children were often scared when told to pose.

The predecessors of the 35-millimeter camera, some of which used bellows and a periscope-type viewfinder, used monochromatic paper-backed film that had to be advanced manually after each exposure. As a result, some pictures turned out as double exposures, but they were often

placed in family albums anyway. This snapshot of a man looking out over water from a dock, with his son by his side, contains a certain aesthetic power.

Over time, family pictures create the sense of a museum, with non-family members rarely included. Some families remove photographs of deceased family members; others prominently display them. Most of us keep photographs of children's birthday parties, but few display or preserve photographs of the unhappy events in life. Family photographs in American culture have, in fact, played a powerful role in banishing the dark side of family experience and keeping alive its ideals, even if those ideals are

unattainable. "Say cheese" and fears will disappear. Visual anthropologist Richard Chalfen calls this "Kodak Culture."

Tourists often behave according to stereotype. Tour buses empty their passengers in front of monuments and famous or scenic places, so that tourists can take pictures. Many shoot with a flash when taking snapshots in large concert halls or in huge cathedrals—although common sense suggests, accurately, that this is useless. When families travel, they pose themselves in front of famous sites as a reminder of their visit, even if the children were tired of being cooped in the family car and not in a mood to "say cheese" for the camera. Automobiles were roomy during the 1950s and 1960s, although an uncomfortable raised hump ran across the center of the floor into the rear compartment; few families owned a station wagon, the forerunner of today's SUV.

"Kodak Culture" on vacation trips mirrors the personality of the person behind the camera. Busloads of tourists descend on a site, all taking photographs of the same building or monument. Groups of tourists or people traveling together pose stiffly in front of the places they are visiting. Some amateur photographers spend a large portion of their vacations taking elaborate photographs—the best ones will hang on their walls as trophies—whereas they never do the same in their own neighborhoods. What motivates these behaviors? For many, taking tourist snapshots fulfills a personal need. Consider the words of one such tourist:

> "When I travel, I usually prefer the photographs taken of me to feature the unique building, sculpture, scenery, or other surroundings, and to depict me as smaller and less significant than these objects. I want the photographs to recall the places visited. I generally don't care whether I will remember what I looked like during my travels . . . I used to take so many pictures on trips that my family ridiculed me. Eventually, it occurred to me that the reason that my memories of my travels were less vivid than theirs was that I hurried to take snapshots rather than making emotional contact with what I was experiencing."

Family Life

Family snapshots also store pictorial evidence of changes in the social patterns of family life: communes, children adopted from other countries or racial backgrounds, the absence of a parent through divorce, the creation of never-married, single-parent families, or families headed by gay or lesbian parents. The traditional patriarchal American family of two Caucasian parents and never more than two children has become a thing of the past.[18] Now, more American families may be Asian, or Latino, or African, or multiracial. Yet, regardless of its composition, family photograph collections continue to present an idealized depiction of harmony, health, prosperity, and good humor.

The passage of time has also affected the size and quality of the photographs themselves. Color photos replaced black-and-white; albums with self-stick plasticine pages—or small albums bound in spiral plastic provided by photo processors—have replaced gummed photo corners. Increasingly, as both parents entered the work force, filing away snapshots and annotating them—traditionally the job of the mother—was replaced in many families by storing prints in a closet. But, whether presented in a leather-bound album or stuffed into envelopes, family photographs offer the best documentation available for the majority of families, of all social levels.

Using industry estimates, by 1983, nearly 12 billion snapshots were taken yearly by amateur photographers in the United States; by 2001, the number had tripled.

Family photographs tell the story of a family as edited by the family members themselves. They sustain sentimental ties in a nation of immigrants.[19] For most people, family albums are the only biographical materials that are left behind at death. Family albums depict relationships within the family and permit those poring through them to construct a family narrative. The pictures reflect the family's vision (mainly the parents') of how to tell its story. Photos can be pulled out of drawers and shown to future daughters- or sons-in-law, as a way of integrating them into the family. They provide a unique perspective, perhaps because untrained photographers—most of us—do not have the skills or the equipment to achieve the special effects that professionals can produce. Professional portraits are taken in the studio or at a ceremonial event, such as a wedding, whereas

family photographs are taken anywhere. Professional photographers usually pose their subjects according to the photographer's idea of an ideal composition, but family members tend to arrange themselves in ways known only to them.[20]

Family photographs differ from all other kinds of photography because they convey emotional involvement, not only uplifting (smiles at a graduation or a family reunion, on a family trip, or at a wedding), but also deeply painful (photographs removed or even mutilated after an angry divorce, for example). Patricia Holland reminds us of the dual role of family albums: they are at the same time intensely personal and thoroughly public. Since album photographs convey social as well as personal meanings, one can see, especially over time, how social conventions shape the ways family members are depicted and how they behave.[21] Before 1940, photographs of men or women over the age of sixty showed them resting, perhaps in a rocking chair, or standing with the aid of a cane. Photos of persons in that age group today may picture them playing tennis, or cooking, or doing anything that is not sedentary.

Here a boy with chicken pox scabs on his body poses with a carefree air. Chicken pox is usually not a serious disease, and American families think little of showing it. If the photograph had been taken in the Third World, the reaction might have been different.

This snapshot shows the opposite of self-conscious posing. The boys are squirming on the floor, absorbed in their own play, and not being asked to comport themselves for the camera.

What Photos Tell Us about Family Life

Some have warned that American society's image of what the family should be seals the world of the individual family within its own happy fantasy. To be sure, family albums rarely show dysfunction or nonconformity—bruises caused by fighting or abuse, illegitimacy, sickness, or depression. Family albums are for forgetting as well as for remembering.[22] In most cases, after all, the family member in charge of the photo album typically chose those pictures to keep and those to discard. Were those that were not kept examples of someone not smiling enough?

Research about the role of photographs in everyday life delves into what social scientists term *material culture*. In the early 1990s, sociologist David Halle visited homes of lower-class, middle-class, and upper-middle-class families in a suburban region of New York to study photographs displayed on walls and on furniture—in contrast to albums, or boxes containing unfiled prints, usually kept out of sight. Regardless of economic level, the homes he visited overwhelmingly omitted photographs of persons not in the nuclear family. When non-kin were represented—in fewer than five percent of all the cases—they usually appeared in wedding photographs as onlookers. Almost none of the home-displayed photographs were of family members who had died. Pictures tended to capture subjects at play—at the beach, on vacation—in direct contrast to the portraits of formally dressed family members characteristic of earlier generations.[23]

Family photographs frequently conform to society's expectation of ideal home life. Most snapshots are taken with the birth of children, often with more snapshots of the firstborn than the later arrivals. Although the elderly are living more years than at any time in history, they do not frequently appear in collections of family photos. In earlier generations, older people lived with their children and grandchildren and eventually were

cared for when they lost their facility for shared work. Today's society puts a premium on independent living, pushing the elderly into special residential communities and, when health declines, into institutional nursing homes. The only groups in American society today that continue the tradition of caring for family members who need it are among the poor and among ethnic groups, such as Hispanics and Asians, where a large, supportive extended family is the norm.

THINK ABOUT THIS

Are we surprised to see a father feeding his infant son? Traditionally, a mother filled this role—although if she were breast-feeding, social convention would frown on a photograph of her nursing. Do many family album snapshots depict the father involved in child rearing? Why?

Today's technological advances have aided snapshot photography, not only because cameras are smaller and film is more sensitive, but because reasonably good equipment is available at a low cost. Disposable cameras, some of which take panoramic photos and some that are waterproof, cost as little as $10, with film. Professional versions of the same kinds of equipment would cost many times that. This photograph was taken at a theme park pool, under the surface of the water.

THINK ABOUT THIS

The photograph below, taken at a water park by a child with a disposable waterproof camera, seems an artistic abstraction. To what extent does it convey the atmosphere of a family vacation?

These boys stand under the trunk of a huge fallen banyan tree, in the aftermath of Hurricane Andrew in South Florida, in August, 1992.

THINK ABOUT THIS

Is the way the photographer posed them an example of "Kodak Culture"? Does insisting that subjects "say cheese" imply that the photographer is demanding that family members show that they are happy, even if they are not? Why are people not often photographed as they are during a regular working day—in work or school uniforms, in business suits, or in worker's attire? Can you find exceptions to this rule?

Diversity

People in the United States are called either "black" or "white." Latinos, not to mention those of partial or full African ancestry, know how foolish the terms are. In nineteenth-century Louisiana, someone with $1/64^{th}$ African ancestry was legally considered non-white, regardless of skin color, type of hair, and facial appearance.

Look at this photograph of a Dominican family's reunion at Thanksgiving in 2001.

THINK ABOUT THIS

Why do Americans refuse to use words describing degrees of skin color, hair texture, shape of lips and noses, in describing racial identity? Why are we so reluctant as a society to be honest about racial categories?

Sample Form for Discussion: Family Snapshots

Consider one of the photographs in the text or from the Web and respond to the following questions:

- What was the occasion for this picture?
- Who suggested that the picture be taken?
- Who took the photograph?
- Who arranged the people in the picture?
- Are the people in the snapshot arranged in any discernable way? Are they ordered by height? Age? Who is in the center? Who is on the periphery?
- Are the spatial relationships in the picture determined by cultural mores or are they accidental?
- Are there any cultural or social practices depicted in the scene that suggest that the subjects are in some way different from mainstream members of society?
- What are your feelings about this photograph? What mood does it evoke?

Final Thoughts

Journalist Michelle Slatalla tells of the evening her daughter invited 16 guests to sleep over at her tenth birthday party. She handed out 17 single use cameras so that all the girls could take party snapshots. Two of the girls, allergic to the family cats, had to be driven home at 2 AM. Slatalla recalls:

> The result was appalling: an expensive pile of blurred, poorly composed photos that cut off half a head, half the cake, half of a ... guest. The trove yielded a series I call 'Fingers on a Lens: Image from Childhood.' Two years later I still shudder when I run across one of the many photos that depict a red-eyed cat sprawled luxuriously on a hypoallergenic sleeping bag.

But she finds herself unable to toss them out:

> In my mind, once a family snapshot is printed it achieves the status of a revered historical record. Would I toss out my daughters' birth certificates or plaster castings of their tiny hands? If some

primitive cultures believe that photos have the power to steal your soul, other primitive people like me believe that even bad pictures can preserve good memories.[24]

Family albums preserve traditional memories: the arrival of an infant, religious ceremonies and celebration, the Fourth of July; rites of passage: graduations, weddings, award ceremonies; and other events out of the idealized imagery of the American family. In recent years, as Americans have been able to travel more—including to foreign destinations—family albums often contain snapshots taken during trips and vacations.

In a chapter titled "How to Date a Browngirl, Blackgirl, Whitegirl, or Halfie," in his novel *Drown*, Dominican-American author Junot D´az's protagonist offers advice about how to arrange his apartment prior to the visit of a girlfriend:

> Take down any embarrassing photos of your family in the *campo*, especially the one with the half-naked kids dragging a goat on a rope leash. The kids are your cousins and by now they're old enough to understand why you're doing what you're doing. Hide the pictures of yourself with an Afro. Make sure the bathroom is presentable.[25]

Family photographs contain the magic of nostalgia. The final scene of the 2001 movie *Harry Potter and the Sorcerer's Stone* translates this into reality. Eleven-year-old Harry, whose parents were murdered when he was an infant, receives—as a reward for his heroics against the forces of black magic—a simple photograph album in which a snapshot of his mother and father with Harry as a young child, comes alive. Such is the power of photographic memory.

Notes

1. "Old Masters Cheated," *New York Times Magazine*, December 9, 2001, 86.
2. Quoted by Jefferson Hunter, *Image and Word* (Cambridge, MA: Harvard University Press, 1987), 1.
3. Ian Parker, "Department of Memory," *The New Yorker*, October 8, 2001, 32.
4. "Road Bed Cut for Trolley, Herkimer County, 1904," Smith-Telfer Photographic RML, New York State Historical Association, Cooperstown, New York.
5. John Tagg, *The Burden of Representation: Essays of Photographies and Representations*, (Amherst, MA: University of Massachusetts Press, 1988), 111.
6. See Michael Lesy, *Real Life* (New York: Pantheon Books, 1976).
7. See Terry Blackburn, "Photographic Theory," at
 http://www.rdrop.com/users/tblackb/photographicphotography.htm
8. Joel Snyder and Neil Walsh Allen, "Photography, Vision, and Representation," *Critical Inquiry*, 2 (August, 1975), 143–69, discussed by Kendall L. Walton, "Transparent Pictures: On the Nature of Photographic Realism," *Critical Inquiry*, 11 (December, 1984), 246–47.
9. Edward Steichen, "Ye Fakers," cited by Kendall L. Walton, "Transparent Pictures: On the Nature of Photographic Realism," *Critical Inquiry*, 11 (December, 1984), 246.
10. See Howard S. Becker, "Do Photographs Tell the Truth?" *Afterimage* 5 (February, 1978), 9–13.
11. Holland Cotter, "A Wild West Transformed by Nostalgia, Assimilation, and Control," *New York Times*, August 17, 2001, B29.
12. Peter [Bacon] Hales, "The Hidden Hand: Jacob Riis and the Rhetoric of Reform," *Exposure* 20:2 (1982), 52. A more complete treatment of the subject may be found in Hale's *Silver Cities: The Photograph of American Urbanization, 1839–1915* (Philadelphia: Temple University Press, 1983). On the concept of *the cordon sanitaire*, see Wiebe, *The Search for Order, 1877–1920* (NY: Hill and Wang, 1966).
13. Maren Stange, *Symbols of Ideal Life: Social Documentary Photography in America, 1890–1950*, (Cambridge and New York: Cambridge University Press, 1989), 23.
14. Nicholas Lemann, "Comment," *The New Yorker*, April 22 and 29, 2002, 55–56.
15. Alexander Leighton, *The Governing of Men* (Princeton: Princeton University Press, 1946) 32.
16. Yoshiko Uchida, *Desert Exile: The Uprooting of a Japanese American Family* (Seattle: University of Washington Press, 1982), 58.
17. Adapted from the list made by Howard S. Becker, "Do Photographs Tell the Truth?" *Afterimage*, (February, 1978), 10–11.
18. The theme affirming patriarchal dominance underlies not only the remarkably successful "Family of Man" exhibit at New York's Museum of Modern

Art in the 1950s, but the 1991 traveling exhibition, *The Circle of Life: Pictures from the Human Family Album* assembled by David Cohen.

19. Alan Sekula, "On the Invention of Photographic Meaning," *Artforum* 13, (January, 1975), 37.

20. See Mary D'Annella, "Portrait of a Family," *Studies in the Anthropology of Visual Communication*, 5:2 (Spring, 1979), 97–114.

21. Patricia Holland, "History, Memory and the Family Album," in *Family Snaps: The Meanings of Domestic Photography*, Jo Spence and Patricia Holland, eds. (London: Virago Press, 1991), 3.

22. See Annette Kuhn, "Remembrance," 17–25, and Simon Watney, "Ordinary Boys," 24–26 in *Family Snaps: The Meanings of Domestic Photography*, Jo Spence and Patricia Holland, eds.

23. David Halle, "Displaying the Dream: The Visual Presentation of Family and Self in the Modern American Household," *Journal of Comparative Family Studies*, 22:2 (Summer, 1991), 217–229.

24. Michelle Slatalla, "A Family Album that Morphs Online," *New York Times*, August 16, 2001, D4.

25. Junot Diaz, *Drown* (New York: Riverhead Books, 1996), 143.

Suggestions For Further Study

ALLEN, JAMES, ed., *Without Sanctuary: Lynching Photography in America* (Santa Fe, NM: Twin Palms Publishers, 2000).

ANDERSON, CAROL M., and ELAINE S. MALLOY, "Family Photographs in Treatment and Training," *Family Process*, 15:2 (June 1976), 259–264.

ATKERET, ROBERT U., *Photoanalysis—How to Interpret the Hidden Psychological Meaning of Personal Photos* (New York: Peter H. Wyden, 1973).

BARTHES, ROLAND, *Camera Lucida* (New York: Hill and Wang, 1981).

BAYER, JONATHAN, *Reading Photographs: Understanding the Aesthetics of Photography* (New York: Pantheon, 1977).

BELLOFF, HALLA, *Camera Culture* (Oxford: Basil Blackwell Ltd., 1985).

BENJAMIN, WALTER, "A Short History of Photography," in Alan Trachtenberg, ed., *Classic Essays on Photography* (New Haven, CT: Leete's Island Books, 1980).

BERGER, JOHN, and JEAN MOHR, *Another Way of Telling* (New York: Pantheon, 1982).

BOERDAM, JAAP, and WARNA OOSTERBAAN MARTINIUS, "Family Photographs: A Sociological Approach," *Netherlands Journal of Sociology*, 16:2 (1980), 95–119.

BRENNAN, BONNIE, and HANNO HARDT, *Picturing the Past: Media History and Photography* (Urbana and Chicago: University of Illinois Press, 1999).

BYERS, PAUL, "Cameras Don't Take Pictures," *Columbia University Forum* 9 (1966), 27–31.

CHALFEN, RICHARD, "Cinéma Naiveté: A Study of Home Moviemaking as Communication," *Studies in the Anthropology of Visual Communication* 2 (Spring 1975), 87–103.

———. "Exploiting the Vernacular: Studies in Snapshot Photography," *Studies in Visual Communication* 7 (1), 2–32.

———. "Family Photography Appreciation." *Studies in the Anthropology of Visual Communication* 1 (Fall 1974), reprinted at http://nimbus.ocis.temple.edu/~rchalfen/Memory.html

———. "Family Photography: One Album is Worth 1000 Lies," in Newman, David, M. ed., *Exploring the Sociology of Everyday Life*, 2d. ed. (Thousand Oaks, CA: Pine Forge Press, 1997), 269–275.

———. *Snapshot Versions of Life* (Bowling Green, OH: Popular Press, 1987).

———. *Turning Leaves: The Photograph Collections of Two Japanese American Families* (Albuquerque: University of New Mexico Press, 1991).

COE, BRIAN, and PAUL GATES, *The Snapshot Photograph: The Rise of Popular Photography, 1889–1939* (London: Asch and Grant Ltd., 1977).

COLLIER, JOHN JR., and MALCOLM COLLIER, *Visual Anthropology: Photography as a Research Method*, rev. ed. (Albuquerque: University of New Mexico Press, 1986).

COONTZ, STEPHANIE, *The Way We Really Are: Coming to Terms with America's Changing Families* (New York: Basic Books, 1997).

CURRY, TIMOTHY J., and ALFRED C. CLARKE, *Introducing Visual Sociology* (Dubuque, IA: Kendall/Hunt Publishing Company, 1977).

GESENSWAY, DEBORAH, and MINDY ROSEMAN, *Beyond Words: Images from America's Concentration Camps* (Ithaca, NY: Cornell University Press, 1987).

GOFFMAN, ERVIN, *Frame Analysis* (New York: Harper & Row, 1974).

———. "Gender Commercials," *Studies in the Anthropology of Visual Communication* 3 (Fall 1976), 92–154.

GOLDBERG, VICKI, *The Power of Photography* (New York: Abbeville Press, 1991).

GOULD, JOHN H., *Outward Bound: Twentieth Century Ocean Travel to Fascinating Faraway Lands* (New York: Outward Bound Company, 1905).

GRAVES, KEN, and MITCHELL PANE, *American Snapshots* (Oakland, CA: The Scrimshaw Press, 1977).

GREEN, JONATHAN, ed., *The Snapshot* (Millerton, NY: Aperture, 1974).

HALL, EDWARD T., *Beyond Culture* (New York: Doubleday, 1976).

HENISCH, HEINZ K., and BRIDGET A. HENISCH, *Photographic Experience, 1839–1914: Images and Attitudes* (University Park, PA: Pennsylvania State University Press, 1993).

HIRSCH, JULIA, *Family Photographs: Context, Meaning and Effect* (New York: Oxford University Press, 1981).

HOCKINGS, PAUL, ed., *Principles of Visual Anthropology* (The Hague: Mouton; Chicago: Aldine), 1975.

HOCKNEY, DAVID, *Rediscovering the Lost Techniques of the Old Masters* (New York: Viking, 2000).

KASLOW, FLORENCE, "What Personal Photos Reveal about Marital Sex Conflicts," *Journal of Sex and Marital Therapy*, 5, 134–141.

KING, GRAHAM, "Say 'Cheese!': Looking at Snapshots in a New Way" (New York: Dodd, Mead and Company, 1984).

KOZLOFF, MAX, *Lone Visions, Crowded Frames: Essays on Photography* (Albuquerque: University of New Mexico Press, 1994).

———, ed., *Photography & Fascination: Essays* (Danbury, NH: Addison House, 1980).

LESY, MICHAEL, *Time Frames: The Meaning of Family Pictures* (New York: Pantheon, 1980).

———. *Wisconsin Death Trip* (New York: Pantheon, 1973).

McLuhan, Marshall, *Understanding Media: The Extensions of Man* (New York: McGraw-Hill, 1964).

Naef, Weston, *Era of Exploration* (Buffalo, NY: Albright-Knox Art Gallery, 1975).

Newhall, Beaumont, *The History of Photography from 1839 to the Present* (Boston: Little Brown, 1992).

Newman, David, M., ed., *Exploring the Sociology of Everyday Life*, 2d ed. (Thousand Oaks, CA: Pine Forge Press, 1997).

Nordstrom, Allison D., "Voyages (per)Formed: Photography and Tourism in the Gilded Age." Ph.D. diss., (Cincinnati: The Union Institute, 2001).

Ohrn, Karin Becker, "The Photo Flow of Family Life: A Family Photograph Collection," *Folklore Forum*, 12 (1975), 27–36.

Penn, Irving, *Worlds in a Small Room* (New York: Grossman, 1974).

The Photograph Book (London: Phaidon, 1997).

Price, Mary, *The Photograph: A Strange Confined Space* (Stanford: Stanford University Press, 1994).

Sekula, Alan, "On the Invention of Photographic Meaning," *Artforum* 13 (January 1975), 36–45.

Shamis, Bob, *The Moment of Exposure* (Ottawa: National Gallery of Canada, 1995).

Sontag, Susan, *On Photography* (New York: Dell Publishing Company, 1978).

Szarkowski, John, *Mirrors and Windows—American Photography Since 1960* (New York: MOMA, 1978).

———. *Looking at Photographs—100 Pictures from the Collection of the Museum of Modern Art* (New York: MOMA, 1973).

Taft, Robert, *Photography and the American Scene* (New York: Dover, 1964).

Thomas, Alan, *Time in a Frame—Photographs and the 19th–Century Mind* (New York: Shocken Books, 1977).

Trachtenberg, Alan, ed., *Classic Essays on Photography* (New Haven, CT: Leete's Island Books, 1980).

———. *Reading American Photographs: Images as History, Mathew B. Brady to Walker Evans* (New York: Hill & Wang, 1989).

Willis, Deborah, *A History of Black Photographers: 1840 to the Present* (NY: W. W. Norton, 2000)

Worth, Sol, ed. introduction, *Studies in the Anthropology of Visual Communication*, 1 (Fall 1974), 1–2.

Yang, John, *John Yang/Mount Zion: Sepulchral Portraits* (New York: D.A.P., 2001).

Zelizer, Barbi, "Reading the Past Against the Grain: The Shape of Memory Studies," *Studies in Mass Communication* 12(2), 214–239.

Top Ten Web Sites for American History

Library of Congress photograph collections at
http://memory.loc.gov/ammem/collections/finder.html

National Archives at
http://www.archives.gov/

National Daguerrean Society at
http://www/daguerre.org/

History of immigration to the United States at
http://www.fordham.edu/halsall/mod/modsbook28.html

History of American sports at
http://www.usembassy.de/usa/sports.htm

Women and social movements, 1776–1990 at
http://womhist.binghamton.edu/

History of American agriculture at
http://www.usda.gov/history2/front.htm

History of American business at
http://www2.h-net.msu.edu/~business/bhcweb/

Photographs of the Great Depression at
http://memory.loc.gov/ammem/fsowhome.html

Civil Rights Movement at
http://www-dept.usm.edu/~mcrohb/

Credits

Preface

Page xii, Courtesy of the Library of Congress, Photograph: Arnold Genthe.

Chapter 1

Page 2, Dorling Kindersley Media Library, Photographer: Dave King; page 4, Getty Images Inc./Hulton Archive Photos, Photograph: Jean Baptiste Sabatier Blot; page 5, Harvard University Art Museums; page 6, The American Photography Museum, Inc.; page 7, Courtesy of the Library of Congress; page 9, The American Photography Museum, Inc.; page 12, The Missouri Division of Tourism; page 14, New York State Historical Association, Cooperstown.

Chapter 2

Page 20, Union Pacific Historical Collection; page 23, Courtesy of the California History Room, California State Library, Sacramento, California; page 24, Courtesy of the Library of Congress; page 25, Getty Images Inc./Hulton Archive Photos; page 26, CORBIS; page 27, Getty Images Inc./Hulton Archive Photos; page 28, Courtesy of The Library of Congress; page 29, Courtesy of The Library of Congress; page 30, The Army Military History Institute; page 31, The American Photography Museum, Inc.; page 33, Courtesy of Andrew Greenlee; page 34, Courtesy of The Library of Congress, Photograph: D.F. Barry; page 35, Courtesy of The Library of Congress; page 36, Courtesy of The Library of Congress; page 37, CORBIS; page 38, The Canadian Museum of Civilization; page 39, Courtesy of The Library of Congress; page 40, Courtesy of The Library of Congress; page 41, National Anthropological Archives/Smithsonian Institution/2860-W; page 42, Courtesy of The Library of Congress; page 43, Courtesy of The Library of Congress, Photograph: Seneca Roy Stoddard; page 44, Courtesy of The Library of Congress; page 45, Courtesy of The Library of Congress; page 46, Courtesy of The Library of Congress; page 47, Charles Van Schaick, "Men in Blackface," State Historical Society of Wisconsin, Van Schaick Collection; page 48, (top) Charles Van Schaick, "Two Infants in Coffins," State Historical Society of Wisconsin, Van Schaick Collection; (bottom) National Archives and Records Administration; page 49, Charles Van Schaick, "Farm Family in Living Room," 1890–1920, State Historical Society of Wisconsin, Van Schaick Collection; page 50, Courtesy of The Library of Congress, Photograph: G. Mages; page 51, Courtesy of The Library of Congress, Photograph: Underwood & Underwood; page 52, National Archives and Records Administration, Photograph: Lewis Hine; page 53, Courtesy of The Library of Congress; page 54, Collections of the Historical Society of Princeton; page 55, The American Photography Museum, Inc.; page 56, Courtesy of The Library of Congress, Photograph: Frances Benjamin Johnston; page 58, Courtesy of The Library of Congress; page 59, Courtesy of The Library of Congress, Photograph: Lewis Hine; page 60, Courtesy of The Library of Congress, Photograph: Lewis Hine; page 61, Courtesy

of The Library of Congress; page 62, Courtesy of The Library of Congress, Photograph, Williams H. Rau; page 63, (top) Robert M. Levine; (bottom) Courtesy of Dolores Newton; page 65, Courtesy of The Library of Congress, Photograph: Lewis Hine; page 66, Courtesy of The Library of Congress; page 67, Courtesy of The Library of Congress; page 68, Archives and Special Collections, University of Miami Library; page 69, Courtesy of The Libray of Congress, Photograph: T.H. O'Sullivan; page 70, The American Photography Museum, Inc.; page 71, Courtesy of The Library of Congress; page 72, Courtesy of The Library Company of Philadelphia, Photograph: George Mark Wilson; page 73, Courtesy of The Library of Congress; page 74, The American Photography Museum, Inc.; page 75, Courtesy of The Library of Congress, Photograph: John Collier; page 76, Courtesy of The Library of Congress; page 77, Courtesy of The Library of Congress; page 78, (top) Courtesy of the Library of Congress, (bottom) Courtesy of The Library of Congress, Photograph: Jack Delano; page 79, Miami-Dade Public Library, Romer Collection; page 80, (top) National Archives and Records Administration, (bottom) CORBIS; page 81, National Archives and Records Administration, Photograph: Sgt. Leon Caverly, USMC; page 82 "Burning of German Textbooks," June 13, 1918. Wisconsin Historical Society, Photograph: Edwin B. Trimpey; page 83, Courtesy of The Library of Congress; page 84, Courtesy of The Library of Congress; page 85, Courtesy of The Library of Congress; page 86, Getty Images Inc./Hulton Archive Photos, Photograph: Lewis Hine; page 87, Courtesy of The Library of Congress; page 88, Robert M. Levine; page 89, Courtesy of The Library of Congress; Photograph: Frances Benjamin Johnston; page 90, Courtesy of The Library of Congress; page 91, CORBIS; page 92, Courtesy of The Library of Congress, Photograph: Marjory Collins; page 93, Courtesy of The Library of Congress; page 94, Courtesy of The Library of Congress; page 95, Archives and Special Collections, University of Miami Library; page 96, Courtesy of The Library of Congress, Photograph: R. Lee; page 97, Courtesy of The Library of Congress; page 98, Courtesy of The Library of Congress; page 99, (top) Courtesy of The Library of Congress, Photograph: Dorothea Lange; (bottom) National Archives and Records Administration, Photograph: George W. Ackerman; page 100, CORBIS; page 101 (top) Courtesy of The Library of Congress, Photograph: Dorothea Lange; (bottom) National Archives at College Park, page 102, Courtesy of The Library of Congress, Photograph: Dorothea Lange; page 103, Courtesy of The Library of Congress; page 104, National Archives and Records Administration Photograph: Clem Albers; page 105, AP/Worldwide Photos; page 106, (top) Courtesy of The Library of Congress, (bottom) Courtesy of The Library of Congress, page 107, (top) Courtesy of The Library of Congress (bottom) Getty Images Inc./Hulton Archive Photos; page 108 Courtesy of The Library of Congress; page 109, Courtesy of The Library of Congress, Photograph: Andreas Feininger.

Chapter 3

Page 110, AP/Wide World Photos; page 112, Courtesy of Library of Congress; page 113, Getty Images Inc./Hulton Archive Photos; page 114, National Archives and

Records Administration; page 115, Courtesy of Janice Hirshon; page 116, Hagley Museum and Library, Wilmington, DE; page 117, Romer Collection, Miami-Dade Public Library; page 118, Courtesy of Library of Congress; page 119, Getty Images Inc./Hulton Archive Photos, Photograph: John Vachon; page 120, (top) AP/Wide World Photos; (bottom) Getty Images Inc./Photodisc; page 121, National Archives and Records Administration Photograph: Russell Lee; page 122, Courtesy of Audrey Sweet, Photograph: Andy Sweet; page 123, The Daily Cardinal Media Corporation, Photograph: Geoffrey Manasse; page 124, Mayor's Press Office, City of Chicago; page 125, (left) Index Stock Imagery, Inc., Photograph: Ewing Galloway; (right) Courtesy of Daniel Hirshon; page 126, NASA Headquarters; page 128, Miami-Dade Public Library System; page 129, Juan Carlos Espinosa; page 130, (top) Miami-Dade Public Library System; (bottom) Courtesy of Audrey Sweet, Photograph: Andy Sweet; page 131, Courtesy of Thomas Born; page 132, Pearson Education/PH Library. Photograph: Eugene Gordon; page 133, Robert M. Levine; page 134, Courtesy of Mary J. Lucas; page 135, Courtesy of Karen J. Orlin; page 136, Courtesy of Ellis Ashkenazi; pages 137 and 138, Courtesy of Karen J. Orlin; page 139, Corbis/Stock Market, Photograph: Chris Collins; page 140, AP/Wide World Photos; page 141, Robert M. Levine.

Chapter 4

Page 144, The Denver Public Library; page 147, Robert M. Levine; page 148, Courtesy of Archives and Special Collections, University of Miami Library; page 149, (top) Courtesy of Archives and Special Collections, University of Miami Library; (bottom) Courtesy of Archives and Special Collections, University of Miami Library; page 150, Courtesy of Archives and Special Collections, University of Miami Library; page 151, Courtesy of Peggy A. Phillip; page 152, Robert M. Levine; page 155, Robert M. Levine; page 156, Robert M. Levine; page 157, Courtesy of Carol and Craig Hendricks; page 158, (top and bottom) Robert M. Levine; page, 159, Robert M. Levine; page 160, Courtesy of Mileyka Burgos.

Index